The Campus History Series

WOFFORD COLLEGE

The Campus History Series

WOFFORD COLLEGE

Dr. Phillip Stone

ARCADIA
PUBLISHING

Published by Arcadia Publishing
Charleston SC, Chicago IL, Portsmouth NH, San Francisco CA

Printed in the United States of America

Library of Congress Catalog Card Number: 2009942698

For all general information contact Arcadia Publishing at:
Telephone 843-853-2070
Fax 843-853-0044
E-mail sales@arcadiapublishing.com
For customer service and orders:
Toll-Free 1-888-313-2665

Visit us on the Internet at www.arcadiapublishing.com

To Herbert Hucks Jr. (1913–1999),
who served as Wofford's librarian and archivist
from 1947 to 1998.
In preserving the college's documentary record,
and as my mentor, he made this work possible.

CONTENTS

Acknowledgments

I am grateful for the support of so many friends and colleagues as I have prepared this book for publication. Dr. Doyle Boggs, associate vice president for communications and marketing at the college, encouraged me to undertake the project. His insights about the college's history over the years have been especially valuable to me, and his suggestions have helped improve the book. Dr. Tracy Revels, chair of the history department, also offered many words of support. My library colleague Shelley Sperka read the manuscript and helped me polish the text. Pat Smith, associate director of communications and marketing at the college, helped locate several photographs from the communications office collection. Mark Olencki, the college photographer, shared his talents and guidance in selecting certain images. Much of Wofford's modern photographic record has been captured through his lens. Dean of the Library Oakley Coburn has been an enthusiastic supporter of this project since its inception and has offered many helpful suggestions. I also appreciate the assistance of Lindsay Harris, my editor at Arcadia Publishing.

The photographs and images in this book document the history of the college and come from a collection built largely by Dr. Herbert Hucks Jr., who graduated from Wofford in 1934 and who served on the college staff from 1947 to 1998 successively as associate librarian, librarian, and archivist. I worked for Dr. Hucks from 1991 to 1994 as a Wofford student assistant, and the library kept inviting me back during summers to be his assistant from 1995 to 1997. After his retirement, I became responsible for maintaining the collection.

Unless otherwise identified, images come from the Wofford College Archives.

INTRODUCTION

Late in his life, Rev. Benjamin Wofford decided that rather than spread his wealth among several different charitable institutions, he would concentrate it in a place where it would have the greatest lasting effect. He founded a college that would serve both to educate Methodists in South Carolina and to help Spartanburg grow into a progressive small town. Known for his thrift and his business acumen, the minister and businessman had been a fixture on Spartanburg's streets for 40 or more years. He had been called to preach some 50 years earlier, had traveled to minister in the wilds of Tennessee, and had been ordained into the Methodist ministry in 1816. Four years later, he left the active ministry to attend to his and his wife's business affairs. Wofford made a small fortune, and nearly 160 years after his death, his legacy lives on in the lives of those who have taught and learned at the college he created.

His $100,000 bequest was to be divided: half for buildings and half for the endowment. Benjamin Wofford's will gave his handpicked trustees the task of selecting a place within Spartanburg County to locate the college. Though the trustees considered offers by some of the county's other communities, there was never much doubt that the county seat of Spartanburg would be the home to the school. In July 1851, in impressive and well-attended ceremonies, these trustees laid the cornerstone of the college's Main Building. They promptly forgot where they had placed it, and a century would pass before its rediscovery in 1953. Thus, from the outset, the college demonstrated one of its long-standing traits, one that came to be called "the Wofford Way," a practice of somehow ending up with a good result despite unusual choices or detours along the way.

Wofford College opened on August 1, 1854, with three professors and seven students on hand, and the student body grew quickly during the first six years. Presiding over the new institution was William May Wightman, the leading Methodist minister in South Carolina. Wightman and his colleagues, professors David Duncan and James H. Carlisle, were soon joined by Warren DuPré and Whitefoord Smith. These instructors guided the school in its earliest years, and by the outbreak of the Civil War, some 61 students had earned bachelor's degrees. The coming of war in 1861 led most of the 79 students then enrolled to leave school, though the college never closed. When the war ended, the endowment, which had grown to some $85,000 invested in Confederate bonds and $17,000 in bank stock, became worthless.

It took the college decades to recover from the loss, but within a few years, enrollment had reached, and even surpassed, that of the prewar years. College life resumed, and Albert M. Shipp, who had succeeded Wightman as president in 1859, set about trying to rebuild the endowment. Expenses in this era far exceeded the college's revenue, which came almost entirely from tuition and Methodist church donations. For most of the late 19th century, faculty members worked on partial pay, a reflection of their dedication. In 1875, Shipp left to join the Vanderbilt faculty, and the trustees selected James H. Carlisle, who had been at the college since 1854, to be the college's

third president. Carlisle, who taught mathematics and astronomy, was called the college's "spiritual endowment," and he saw producing students of high moral caliber as his principal duty. He was not an administrator in the modern sense: he did not raise money to rebuild the endowment, he did not select faculty, and he left most executive tasks to the trustees or to other faculty members. A faculty colleague served as financial agent and took responsibility for soliciting gifts. These fund-raisers worked in difficult times; the college's income in 1881–1882 was less than $9,000.

Students in the years after the Civil War brought fraternities and athletics to campus. The first Greek-letter fraternity was Kappa Alpha, which arrived in 1869, followed shortly thereafter by Chi Psi, Chi Phi, Sigma Alpha Epsilon, Pi Kappa Alpha, and Kappa Sigma. The earliest baseball games were purportedly held between students and federal soldiers stationed in Spartanburg during Reconstruction. Intercollegiate games began in the late 1880s. Wofford took part in the first intercollegiate football game in South Carolina against Furman University on December 14, 1889. The Wofford team won, 5-1, and won a rematch in Greenville a month later, 2-1. Basketball and gymnastics rounded out late-19th-century athletics additions. The college also embarked on a short-lived experiment in coeducation, admitting two women into each class beginning in 1897. By 1900, eight women had enrolled, and all eight graduated between 1901 and 1904, but the trustees abandoned the experiment at that point.

President Carlisle indicated his desire to retire in 1901, and in June 1902, the trustees selected Prof. Henry Nelson Snyder, a Tennessee native and Vanderbilt graduate, to be the college's fourth president. Snyder, 37 and a professor of English at Wofford since 1890, became the college's youngest president up until that time. He was a more active leader than Carlisle had been, served on a number of state and Methodist boards, and assumed a greater role in selecting his faculty colleagues, building a staff that served alongside him for most of the first half of the 20th century. Snyder also presided over growth in the student body. In his first year as president, Wofford enrolled 196 students, its largest student body ever, but within two years that number had increased to 220, and by 1912, 308 students attended classes. Snyder's presidency also brought the first major changes to the campus physical plant, with a new science building, a library, and a dormitory all opening in his first 10 years. These followed on the additions in the 1890s of new faculty homes, a gymnasium, and buildings for the Wofford Fitting School, a preparatory school opened in 1887. During this era, literary societies created three student publications and provided much of their staffing for decades. The literary societies are gone, but the three student publications live on. The outbreak of World War I brought the precursor of the Reserve Officer Training Corps (ROTC) to the campus, and most students were members.

By 1924, the endowment had reached almost $300,000, and Wofford's income and expenses equaled about $60,000 a year. Fully one-fifth of revenue came from the Methodist church. The college gave many tuition scholarships, but students still had to pay for books and room and board. When the Great Depression hit, enrollment dropped by 50 students for one year, which amounted to one-eighth of the student body. Enrollment stabilized, and the college borrowed money for faculty salaries for a few years, but by 1933, even those funds began to run out. In June 1933, the faculty reported to the board that they had not been paid since November. The trustees found funds for professors, though for the next several years, they only received a portion of their salaries. Only in 1939 were the trustees able to restore pay to pre-Depression levels.

As his presidency of 40 years drew to a close, Snyder and his faculty colleagues celebrated the awarding of a chapter of Phi Beta Kappa to the college in 1941. This was a national recognition of the academic quality and the more rigorous standards implemented during Snyder's tenure. On his retirement in 1942, Snyder was succeeded by Dr. Walter Kirkland Greene, a Wofford graduate of the class of 1903. Greene, a South Carolina native, had continued his education at Vanderbilt and Harvard, where he earned a Ph.D. With World War II underway, the college struggled once again to maintain its enrollment. In February 1943, Wofford's remaining students went to Converse College or Spartanburg Junior College to continue their studies, and the campus was turned over to the U.S. Army for use as a college training center for aviation students. The campus remained in the army's hands through the summer of 1944.

Barely nine days after World War II ended, Greene announced an ambitious development plan called the "Wofford of To-morrow." The campus expected a rise in enrollment due largely to veterans who would be able to attend with GI Bill benefits. The plan called for a number of new facilities on campus to meet this surge, including expansion of the library, renovation of Main Building, and the construction of a new science hall and new residence halls, a hall for the honorary societies, and a War Memorial Chapel. At the same time, South Carolina Methodists were debating the future of church-related higher education in their denomination. The subject continued to arise because the Methodist conference did not feel that it had the resources to continue supporting three schools—Wofford, Columbia, and Lander colleges. Some leaders wanted to merge all three institutions into a new campus north of Spartanburg, but the supporters of the two other schools resisted. The result was the sale of Lander and the creation of a single board of trustees and administration for Wofford and Columbia. Whether this was a precursor to an eventual merger of the two colleges is a matter of conjecture, but it proved ultimately unworkable, and the church restored separate administrations in early 1951. The confusion regarding the church's vision hurt the college's development campaign and kept many of the planned buildings from ever being constructed. Greene announced his intention to retire in the summer of 1951.

A year later, Francis Pendleton Gaines Jr., a Virginian and a historian, became Wofford's sixth president. Gaines, at age 33, was the college's youngest president, and he led Wofford through its centennial, campaigned to get the 13-member board of trustees enlarged to 21, and tried to find new sources of income. After five years, he left the college, taking a position at the University of Arizona. A number of professors who came just before or during his tenure stayed into the 1980s or 1990s, becoming some of the most influential faculty members for generations of students. The academic dean from 1953 to 1969, Philip S. Covington was responsible for recruiting many of these instructors. A much-loved personality among a corps of characters, Covington also served as acting president for a year after Gaines's resignation.

Whereas they had gone for youth in choosing Gaines, the trustees went for experience in selecting Charles Franklin Marsh to be the college's seventh president. A native of Wisconsin, Marsh had taught economics and had served as academic dean at the College of William and Mary. His administration addressed many of the deferred construction plans. With the sponsorship of trustee Roger Milliken, Wofford built a new science building. The century-old Main Building, which was badly in need of repair, was virtually gutted and rebuilt from the inside out. The size of the student body continued to grow past 1,000, and the college built several new dormitories to house students. Near the end of Marsh's term, the school also began planning for a new library to replace the 1910 building and a new dining hall.

These significant additions to the physical plant were just the beginning of a decade of substantial change at Wofford. Between 1964 and 1976, the college moved through desegregation, liberalization of student life, curricular reform, and coeducation. By 1964, most Methodist-related colleges throughout the country were admitting African American students, and many of Wofford's constituencies believed that it should do the same. Other groups, particularly older alumni and churches in the South Carolina Lowcountry, were strongly opposed to desegregation. After a year of study, the board of trustees voted in May 1964 to admit all qualified students regardless of race. Marsh received a considerable amount of mail when the decision was announced, much of it supportive but some quite hostile. A number of churches withdrew financial support, but friends of the college stepped in to help Wofford through the transition. Curricular changes also came in 1968, as the college created Interim, a one-month term in January for faculty and students to explore nontraditional subjects, undertake internships, or travel.

The pace of change quickened as Paul Hardin III, then a law professor at Duke, succeeded Marsh in 1968. His tenure saw the creation and implementation of a new student conduct code, a new student government structure, and the admission of women as day students. The new code permitted students to drink alcohol on campus in limited areas, but the change from being an officially dry campus was unpopular with many of the college's supporters. The administration also did away with "rat season," a period akin to fraternity pledgeship for all freshmen in which

the new students were required to learn college history and traditions, and perform assorted tasks, like shoe-shining, for upperclassmen. The admissions office worked harder to recruit African Americans, and Hardin's term saw the first African American students earn their degrees. A grant from the National Endowment for the Humanities helped create a new interdisciplinary freshman seminar in the humanities that all entering students were required to take.

After four years at the helm, Hardin left to accept the presidency of Southern Methodist University, and Dean of the College Joab Mauldin Lesesne Jr. became Wofford's ninth president. A historian, Lesesne saw his role primarily as consolidating the changes that the previous two administrations had implemented. In his first four years, he steered the move to full residential coeducation through the board of trustees, and the first class of women resident students entered in 1976. He also oversaw a series of major building projects, beginning in 1980 with the Campus Life Building and its Benjamin Johnson Arena for basketball. The rejection of a grant application in 1985 by the F. W. Olin Foundation prompted both the trustees and administration to evaluate how the college could improve on an already good product. The result was a document entitled "To Improve Quality," a master plan that called for increasing financial support for students, new faculty positions, improved facilities, and making the school into a nationally known liberal arts college. The Olin Foundation subsequently awarded Wofford a grant to build the F. W. Olin Building on campus. The college moved its athletics affiliation from the NAIA into NCAA Division II in 1988, to Division I in 1995, and, in 1997, joined the Southern Conference. In 1995, the Carolina Panthers, an NFL franchise awarded to alumnus Jerry Richardson, began holding their training camp on campus. New athletics facilities included the Reeves Tennis Center, the Richardson Physical Activities Building, Gibbs Stadium, and Russell C. King Field, the renovated baseball facility.

The experience for students improved under the Lesesne administration, and this improvement continued after Lesesne concluded his 28-year presidency. In 2000, Dr. Benjamin Bernard Dunlap became the college's 10th president. A Rhodes scholar with a doctorate from Harvard, Dunlap encouraged faculty development and the growth of arts programming on campus, and he managed a gradual increase in the size of the student body to about 1,450 students. His administration completed an expansion of the Roger Milliken Science Center, construction of the Village apartments for Wofford seniors, and extension of the campus to include an environmental studies center at Glendale. Foreign study, which had grown throughout the 1990s, became a significant part of the college experience as students became global citizens. As it approaches its 160th year, Wofford continues its focus on undergraduate liberal arts education in a community setting where students develop into mature and thoughtful members of society.

One

THE 19TH-CENTURY COLLEGE
1854–1902

Wofford's first half-century saw a prosperous beginning followed almost immediately by the calamity of war and decades of struggle. Despite the passage of time, a number of institutions with origins in the college's first 50 years remain today. Greek-letter fraternities and intercollegiate athletics began in the years after the Civil War. Other groups, like the literary societies, are gone, but some of the earliest books in the library, the older portraits in the college art collection, and the three student publications are part of their legacy. Several buildings constructed during this era, including four of the five original faculty homes and the Main Building, are still in daily use on the campus.

Students in these earliest years studied a curriculum heavy in Latin and Greek, with other subjects such as religion, history, math, grammar, and the sciences. Living on campus, many professors worked in their homes and held meetings with students there. Trustees chose not to build residence halls, instead expecting that students would board with families in Spartanburg. The belief was that they would get into less trouble living in a homelike environment. Students sometimes sought and received permission to live in the Main Building, and a group even operated a dining room, known as Wightman Hall, in the building.

A tradition of close faculty-student interaction had its roots in the earliest days of the college. One professor who embodied the practice of one-on-one teaching was James H. Carlisle. The Doctor, as he was known, was a part of the college and lived on campus from the day it opened until his death 55 years later. Images in this chapter show Wofford's development in its first 50 years, the people who taught and studied there, the organizations they founded, and the buildings they saw every day.

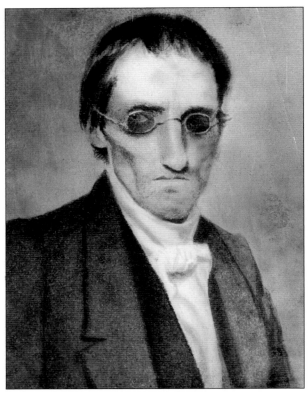

Born in 1780 in southern Spartanburg County, Benjamin Wofford (left) became a Methodist preacher but retired from the active ministry in 1820 when his wife inherited all of her family's property. Benjamin and Anna Todd Wofford lived on the family farm south of Spartanburg until her death in 1835. Benjamin remarried the next year and lived with Maria, his second wife, in this house (below) on Spartanburg's courthouse square for the last 10 years of his life. Maria Wofford left Spartanburg after Ben's death, though two of her nephews later attended the college founded by her husband's will. The portrait is an ink drawing by artist William H. Scarborough.

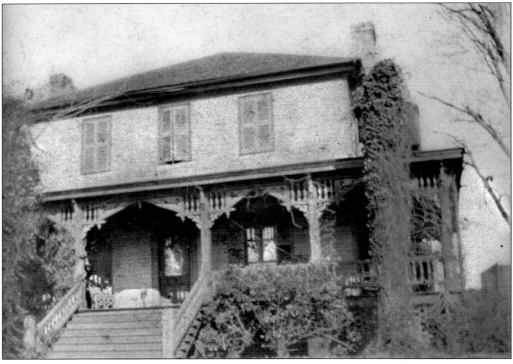

Born in Charleston in 1808, William May Wightman was a leading Methodist minister and church newspaper editor. Benjamin Wofford's will named Wightman a trustee of the college, and he became the first chairman of the group. Before the school opened, fellow trustees elected him the first president. He served five years, leaving in 1859 for Birmingham-Southern. This portrait was by his brother, the artist Thomas Wightman.

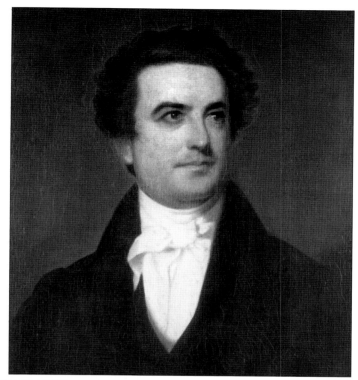

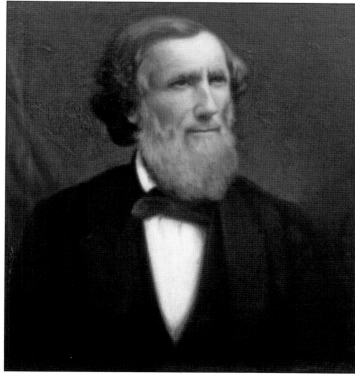

The Reverend Hugh Andrew Crawford Walker was a friend and adviser of Benjamin Wofford, and D. D. Wallace's *History of Wofford College* credits Walker with giving Wofford the advice, "why not found a college?" Walker was named to the first board of trustees, and when his brother-in-law, William Wightman, became president, Walker became chairman of the board of trustees. This portrait was likely by Thomas Wightman.

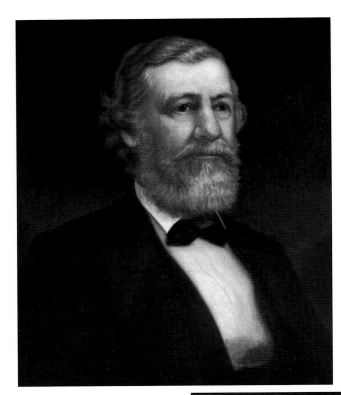

Warren DuPré was born in Mount Pleasant, South Carolina, in 1816. He held teaching positions at Randolph-Macon College and at academies in Charleston and Newberry. In 1850, he helped found the state teacher's association. During his first year at Wofford, he traveled in the North to buy scientific equipment and to study chemistry and geology at Yale. He left Wofford in 1876 to become president of Mary Washington College in Virginia.

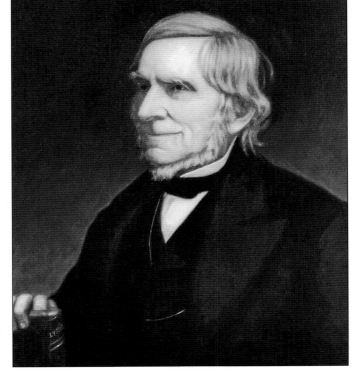

Born in Ireland in 1791, David Duncan was educated at the University of Glasgow and joined the British navy before coming to teach in Virginia. He became a professor at Randolph-Macon College, where he met William Wightman. In 1854, Duncan was invited to join the Wofford faculty as professor of ancient languages, a chair he held until his death in 1881.

WOFFORD COLLEGE
COMMENCEMENT,
JULY 14, 1858.

A procession will be formed in front of the President's House, at 9 1-2 o'clock, A. M.

Gentlemen are requested not to take seats in the Chapel until the Procession enters.

EXERCISES IN THE CHAPEL:
PRAYER.

MUSIC—*Festival March.*

SALUTATORY ADDRESSES, - - - W. M. CUMMINGS.

MUSIC—*Egeria Waltz.*

T. F. BARTON, - - - - - - Conscience.

MUSIC—*Sontag Polka.*

J. F. SHACKELFORD, "If the sons of Priam slumber, Troy must fall."

MUSIC—*March from Norma.*

J. O. HARDEN, - - - - Consequences of Marathon.

MUSIC—*New England Polka.*

E. H. HOLMAN, - - - : - - The Crusades.

MUSIC—*The dearest spot an Earth to me is Home.*

J. B. JORDAN, - - - - - Progress of Opinion.

MUSIC—*Rainbow Schottische.*

J. A. MOORE, - - "The Paths of Glory lead but to the Grave."

MUSIC—*"Love Not." Quick step.*

W. W. DUNCAN, - - The Bible, a Crystal Palace for all Nations.

MUSIC—*Marseilles Grand March.*

R. B. TARRANT, Our obligations to our predecessors and debt to posterity.

MUSIC—*Washington's Grand March.*

A. W. MOORE, - - - Remember that Brave Resolution.

MUSIC—*Huntsman's Chorus.*

J. C. HARDEN, - - - - - Distinction of Authorship.

MUSIC—*Crystal Palace Schottische.*

DEGREES CONFERRED.

MUSIC—*Hail Columbia.*

A. W. MOORE, - - - VALEDICTORY ADDRESSES.

MUSIC.

DOXOLOGY—*"Praise God from whom all blessings flow."* By Audience.

BENEDICTION.

Early commencements were multiday affairs with a series of lectures, debates, a baccalaureate service, and other events leading up to the graduation ceremony itself. This program, from the 1858 commencement, is the oldest available in the college archives. Each member of the graduating class gave a short address before the president awarded degrees. The content varied from classical to Biblical subjects. Sometimes professors gave addresses as well, particularly when they were new to the faculty. Diplomas were printed in Latin. Among the other traditions that started in these early years was the singing of the hymn "From All That Dwell Below the Skies."

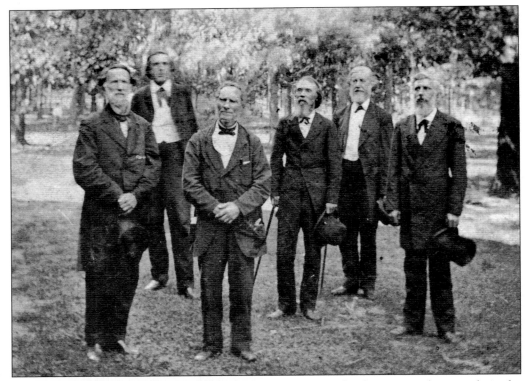

This 1872 faculty group photograph is the oldest in the archives. Instructors from left to right are Whitefoord Smith, English; James Carlisle, mathematics and astronomy; David Duncan, ancient languages; A. H. Lester, history and Biblical literature; Warren DuPré, natural sciences; and college president A. M. Shipp, mental and moral philosophy.

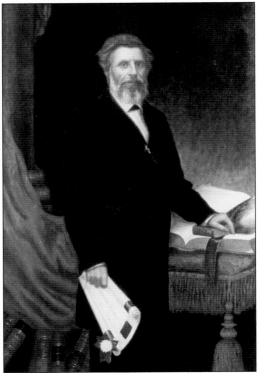

Albert Micajah Shipp was a North Carolina native and Methodist minister when he was called to Wofford's presidency in 1859. He served for 16 years, seeing the college through the tumultuous Civil War and Reconstruction years. Shipp left in 1875 to join the theology faculty at Vanderbilt University, where he served as dean from 1882 to 1885. He retired to Marlboro County, South Carolina, and died in 1887.

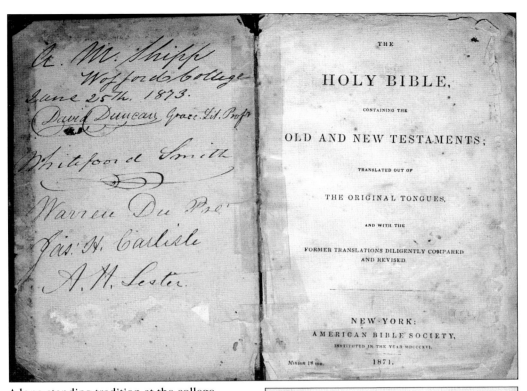

A long-standing tradition at the college has been the presentation of a King James translation of the Bible signed by the faculty and staff to each graduate. This Bible (above), from 1873, is one of several that have been given to the archives by families of alumni. The inside cover shows the signatures of the six members of the teaching staff. The 1875 commencement program (right), printed in Latin, shows the college was still strongly influenced by classical languages. This was Shipp's last commencement as Wofford's president, and in the following year, James Carlisle gave his address to the graduating class in English, not in Latin.

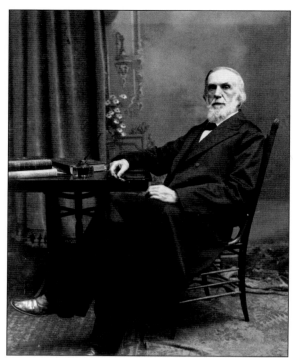

Born in Winnsboro, South Carolina, in 1825, James H. Carlisle graduated from South Carolina College in 1844. After teaching for several years in preparatory schools around Columbia, he joined Wofford's faculty as professor of mathematics and astronomy in 1854. Carlisle became the third president in 1875, serving until 1902. In later years, he gave up some of his courses, focusing on teaching morality and ethics to his students.

By 1894, six younger professors had joined two older ones. The faculty included, from left to right, (first row) Whitefoord Smith, English; James Carlisle, president; and Daniel A. DuPré, natural sciences; (second row) S. R. Pritchard, mathematics; Henry Nelson Snyder, English and German; John C. Kilgo, metaphysics and political science; E. B. Craighead, Greek and French; and J. A. Gamewell, Latin.

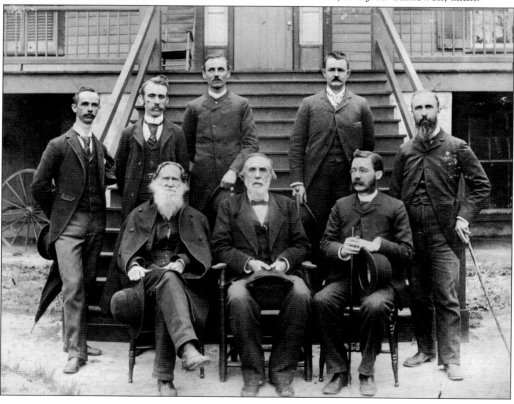

The son of original faculty member David Duncan, William Wallace Duncan graduated in 1858, and after being ordained into the Methodist ministry, he returned to teach at Wofford and serve as its financial agent in 1875. Elected bishop in 1886, he chaired the board of trustees until his death in 1908. Bishop Duncan made his headquarters in a large Victorian house he built near the campus.

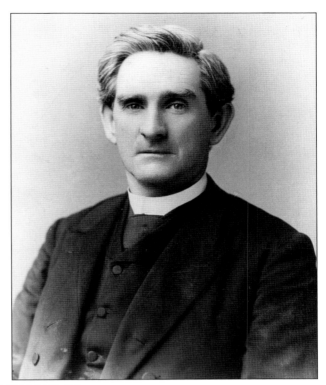

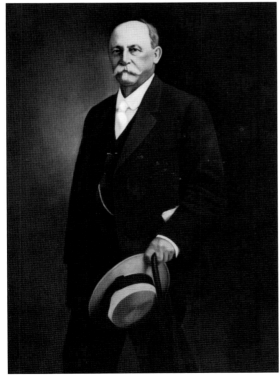

Samuel Dibble was born in Connecticut and attended the College of Charleston before transferring to Wofford in 1855. He took two years' worth of classes in one year and, in 1856, became the college's first graduate. Known as the grand old man of Orangeburg, he was elected to Congress from South Carolina in 1881, serving with distinction for five terms.

Pictured here in his robes as president of the Calhoun Literary Society, Thomas G. McLeod was a member of Wofford's 1892 graduating class. He became the first Wofford alumnus to serve as governor of South Carolina when he was elected in 1922; he was reelected in 1924.

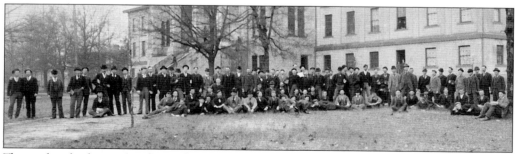

The student body poses in front of Main Building during the 1891–1892 academic year in one of the oldest such photographs. The college registered approximately 160 students that year, so this image includes about two-thirds of the enrollment.

Horace L. Bomar, an 1894 graduate, is pictured here as president of the Calhoun Literary Society. Society presidents were elected for terms that ran for about a third of an academic year, which allowed more members of a class to hold various offices in a society. Presidents generally wore robes like those worn by a judge or the presiding officer of a legislative chamber.

Chesley Carlisle Herbert was president of the Preston Literary Society. Also a member of the class of 1892, he became a Methodist minister in South Carolina like his father. His brothers also graduated from Wofford and were leading Methodist ministers in the state. Shortly after graduation, C. C. Herbert taught English at Wofford for a year.

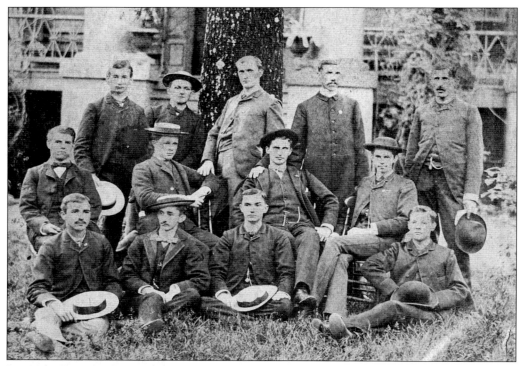

In 1884, eleven students graduated from Wofford, so this picture of the class of 1884 includes at least two who did not complete their degrees. One of those who did graduate, Arthur Galliard Rembert (second row, far right) returned to teach at Wofford. Students often came for less than four years, leaving for family, financial, or other reasons.

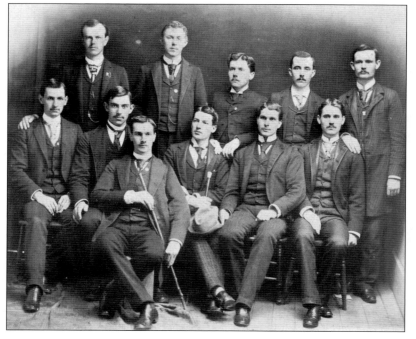

The 11 members of the class of 1890 sit together for this portrait. Most classes in the 1880s and early 1890s had fewer than 15 graduates. President Carlisle insisted on keeping the student body small as a way of encouraging individual instruction and the development of close relationships between professors and students.

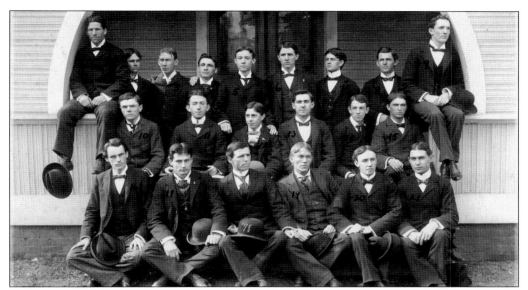

The 21 graduates of the class of 1898 pose in front of the newly completed Burnett Gymnasium. Several members went on to distinguished careers in education, the ministry, and law. Larger classes in the late 1890s foreshadowed growth during the early 20th century.

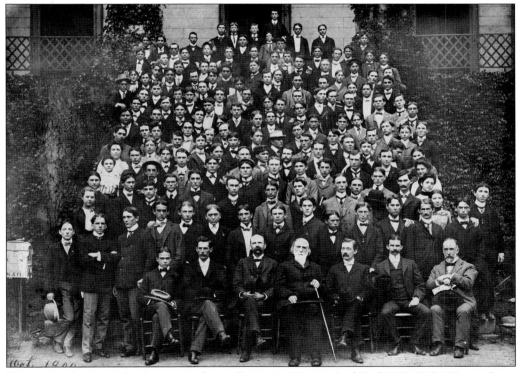

The student body and faculty pose in front of Main Building in the fall of 1900. With 188 members, enrollment was the highest in the college's history to that point. Students include eight women, two in each class. Coeducation was an experiment encouraged by the Methodist conference, but few women enrolled, and those who did felt isolated.

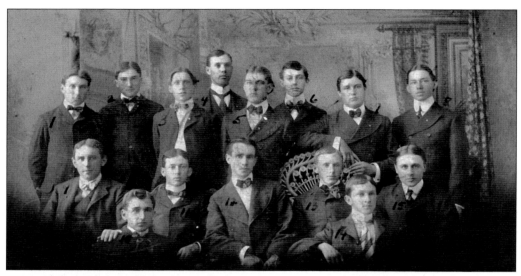

Kappa Alpha Order, established at Wofford in 1869, was the college's first Greek-letter fraternity. Its founder at Wofford was William A. Rogers, who brought the chapter when he transferred from Washington and Lee. This portrait is of its members in the 1901–1902 academic year. The fraternity's papers are in the college archives.

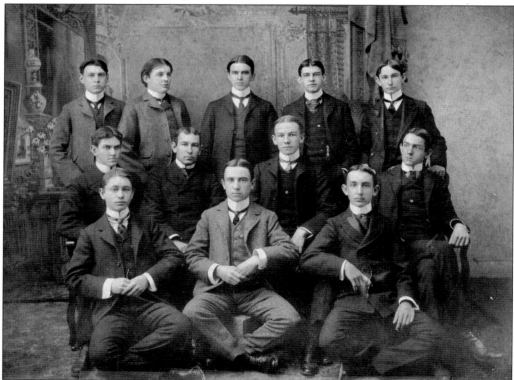

Chi Phi came to Wofford in 1871, shortly after Kappa Alpha. This portrait is of the members in the 1899–1900 school year. When the college reinstated fraternities in 1915, after banning them for nine years, Chi Phi's national organization refused to reestablish a chapter on campus.

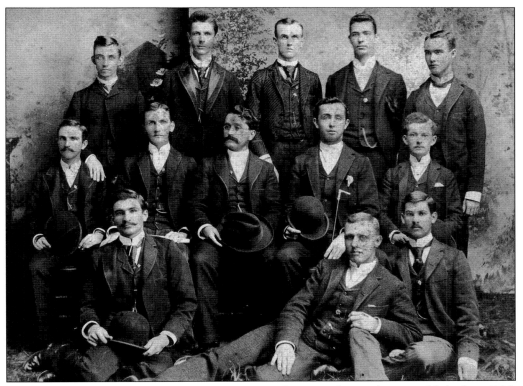

Sigma Alpha Epsilon is the second-oldest existing fraternity, having been established in 1885. This portrait shows the brothers in 1891. Occasionally members who were graduates, faculty, or residents of the community would be involved in a fraternity and would appear in a portrait. Sigma Alpha Epsilon's papers are in the school's archives.

Established in 1891, Pi Kappa Alpha was absent from campus for nearly 50 years, only being reestablished in the early 1950s. This portrait shows Nu chapter brothers in 1903, shortly before disagreements between fraternity and anti-fraternity men led the trustees to suspend fraternities for nearly a decade. Most of the clubs at Wofford in the late 19th century were small, and only one had more than 10 active members in 1904.

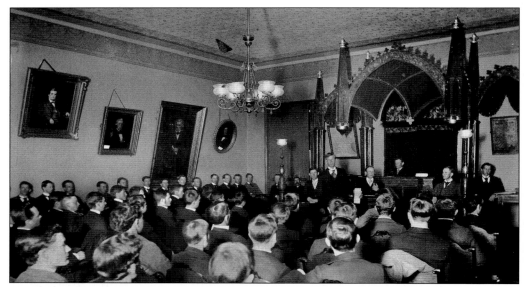

The literary societies were almost as old as the college itself. The Calhoun Literary Society was the elder, formed in October 1854, with the Preston Literary Society forming in 1858. The Calhoun Society took its name from John C. Calhoun; the Preston, from Sen. William C. Preston. These societies were essentially debating and oratorical clubs. They held weekly meetings, argued various subjects, heard orations, and judged their own debating and speaking skills. It was important in the oral culture of the 19th-century South for students to have a chance to practice these abilities, and the faculty made membership mandatory for more than 50 years. The Calhoun Society (above) is pictured during a meeting in 1903. The Preston Society (below) poses in front of Main Building in 1892.

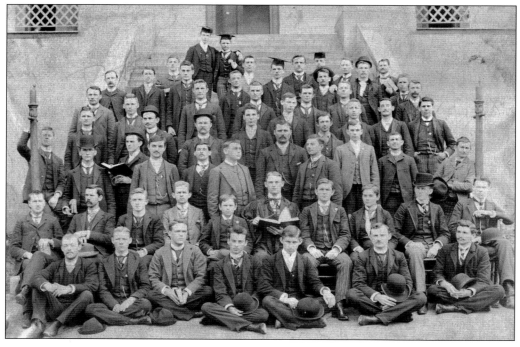

Each society had its own meeting hall in the Main Building, located on the top floor on either side of the chapel. They raised money from their alumni to furnish these rooms, and each group commissioned or owned some significant works of art. The Calhoun Society (above) commissioned a large painting of John C. Calhoun from the artist Albert Capers Guerry. Initially members were not able to afford Guerry's fee, so he exhibited the painting around the state until they could pay him. When the Preston Society (below) informed its namesake that members had chosen to name the group in his honor, William C. Preston sent a bust of his uncle, Patrick Henry, with the message, "God bless those dear boys at Spartanburg."

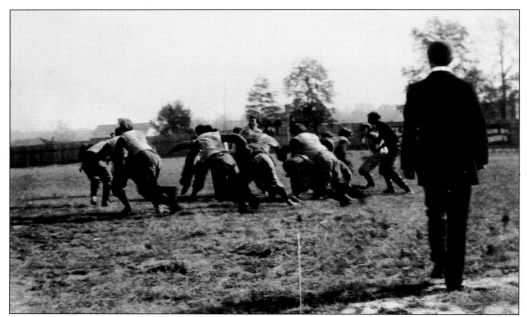

The college first fielded an intercollegiate football team in 1889. The team pictured here is playing in a game against the University of Georgia in 1894. The Terriers lost 10-0. Records of the first 12 years of football are thin, but those that do exist show Wofford winning 10 and losing 12 games between 1889 and 1901.

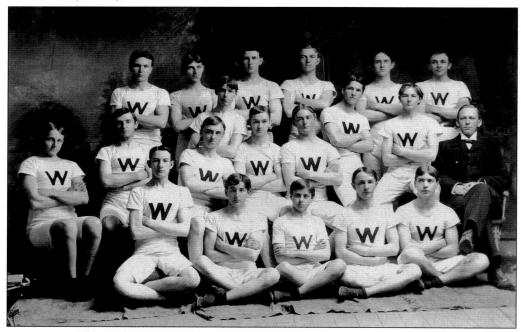

A. M. Chreitzberg, class of 1895, pictured wearing the suit, coached the 1897–1898 gymnasium team. The *Journal* describes a team exhibition in December 1897 as including a dumbbell drill and horizontal bar, ring, parallel bar, and horse work; followed by vaulting, tumbling, and pyramid-building. Fayssoux DuPré (first row, far left) was also a talented pitcher on the baseball team.

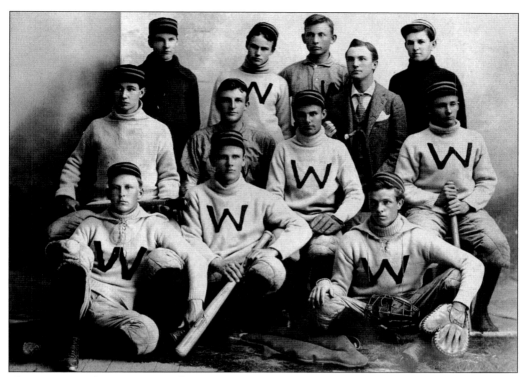

The most popular sport at Wofford around 1900 was baseball. The college had a number of legendary teams and players in this era. They did not play many games, and each contest was arranged separately by managers. An April 1895 article notes that the Boston and Brooklyn clubs had been in Spartanburg and some Wofford athletes had played with them. Pitcher A. M. Chreitzberg (first row, left) poses with the 1895 team (above). Chreitzberg reportedly never lost a game at Wofford. The 1900 team (below) won all nine of its games and was part of a 16-game winning streak.

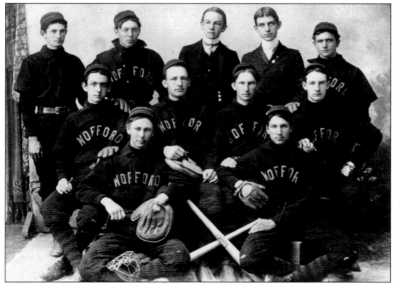

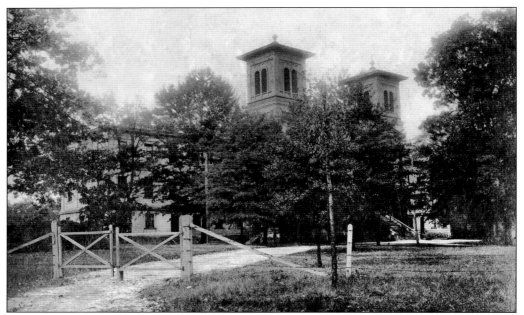

For much of the college's first 50 years, Main Building was the college. Designed by Charleston architect Edward C. Jones and built by Asheville contractor Ephraim Clayton in the Italianate, or Renaissance Revival, style, the building contained all classrooms, the library, laboratories, and offices. A large chapel on the second floor was the site of major college events, and every Wofford student has been in that room.

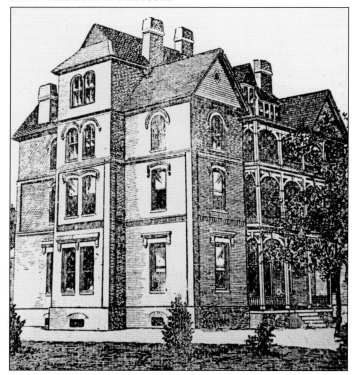

Alumni Hall was built in 1888 when a group of graduates, led by E. L. Archer, asked the trustees to allow them to build a dormitory for the college instead of a group of cottages for students. The building, originally four stories, became the home of the Wofford Fitting School in 1895. It lost two of its floors in a fire on the night of January 17, 1901.

Built in 1897, the Wilbur E. Burnett Gym was named in 1900 for the leading donor, a member of the class of 1876. To that point, the college had no athletic facilities save for a Main Building room with some gymnastic equipment. Students complained in 1896 that "a great part of the sickness among our students is due to a want of exercise." The gym later became a recreational hall.

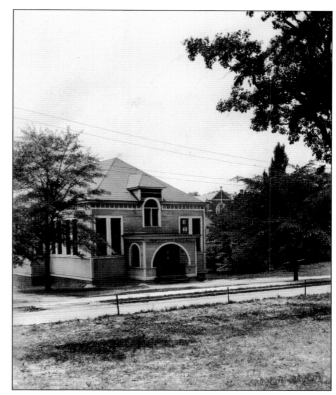

President Carlisle (below, on the porch) lived in this house from 1854 until his death in 1909. When he became president, Carlisle refused to move into the larger president's home, declaring that this residence was fine enough for him. Later the abode of historian Dr. D. D. Wallace, it is now home to the dean of students.

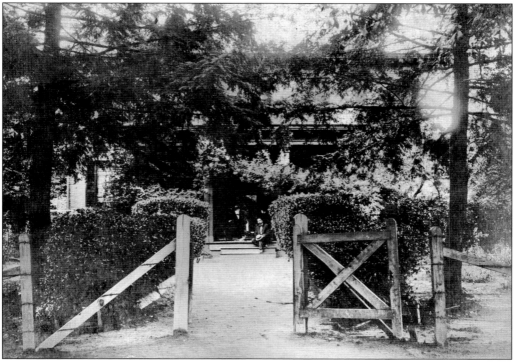

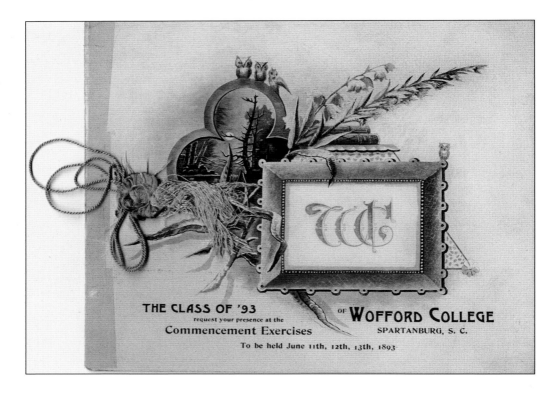

THE CLASS OF '93
request your presence at the
Commencement Exercises
OF WOFFORD COLLEGE
SPARTANBURG, S. C.
To be held June 11th, 12th, 13th, 1893

Commencement became more elaborate in the 1890s. The program shows that events lasted for three days, and the classes were still small enough that each graduate had an opportunity to speak. Literary societies sponsored class debates, and the alumni association met, presented awards, and sponsored the annual alumni address. Receptions stretched well into the night, and the professors' campus homes were filled with visiting alumni, trustees, and other guests.

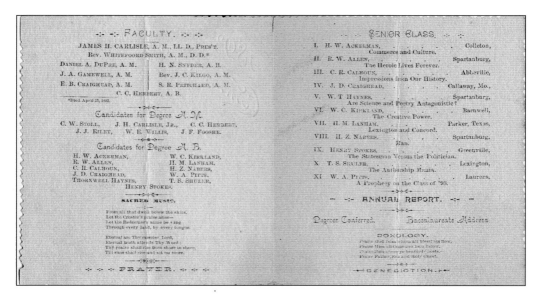

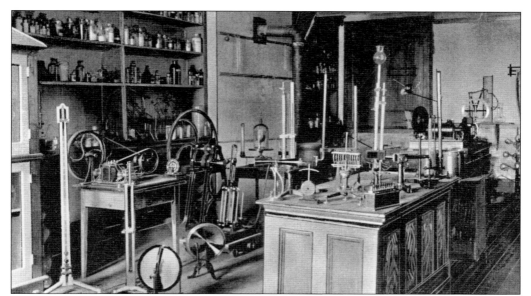

Located in Main Building, this was the college's first chemistry lab as it appeared in *Wofford College Illustrated*, the college's first pictorial brochure, published in 1898.

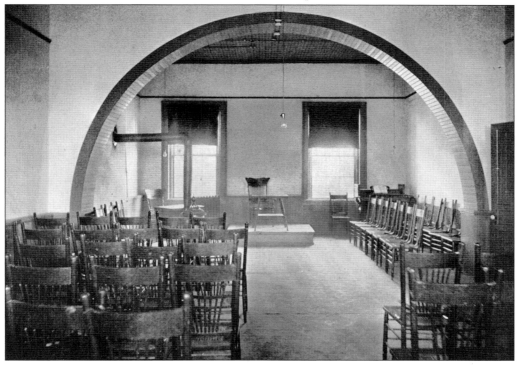

Following several years of student-led prayer meetings, students in 1879 formed a Young Men's Christian Association (YMCA). Within 10 years, seven-eighths of the students on campus were members, and this was their room in Main Building. Members taught Sunday school and worked, according to Wallace, "in the neglected parts of town." Later the YMCA began publishing an annual student handbook. The group remained active into the 1930s.

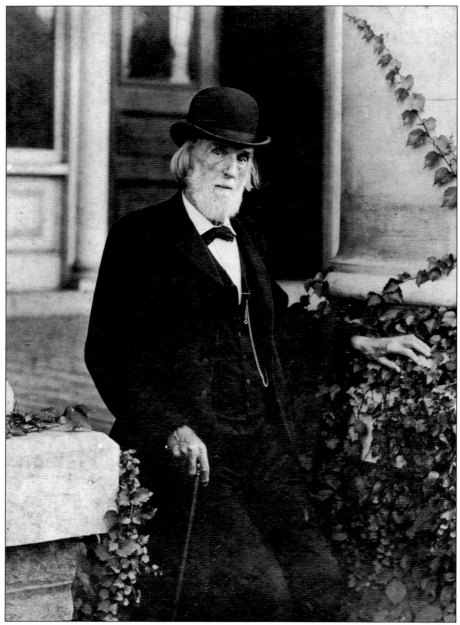

James Carlisle led the college from Reconstruction to the beginning of the 20th century, and the level of respect and esteem with which students and faculty alike treated him is hard to describe today. Wallace's *History of Wofford College* treats him almost as a saint. Carlisle's students remembered him both for the moral lessons he taught them and for some of his aphorisms uttered in chapel. One of these perhaps speaks to the focus of the college under his presidency: "Scholarship and character are too close together for a young man to build up the one and at the same time tear down the other." And another may still hold true today: "While you are planning to spend a dollar foolishly, your parents are planning how to save a dollar to keep you in college." His retirement in 1902 and his death in 1909 marked the end of the college's founding era.

Two

CONTINUITY AND CHANGE
1902–1942

Henry Nelson Snyder's 40-year presidency saw the academic reputation of the college grow, although Wofford remained in a precarious financial position for most of his tenure. Snyder oversaw the first substantial changes to the college's physical plant, with a new science building, a new library, a new large dormitory, and two new fitting school buildings. Later a new athletic facility—large enough to hold basketball games—was opened.

Over the course of 40 years, student life became more modern, as automobiles, movies, and radio arrived in Spartanburg. Early in Snyder's tenure, the trustees banned fraternities because of constant agitation between fraternity and anti-fraternity men and intercollegiate football because it was considered violent. Students agitated and protested, albeit politely, and submitted repeated petitions to the trustees pleading for the return of both. Eventually the board relented, though they gave the faculty authority to govern both fraternities and football. Student pranks were as common as ever, but discipline could be quite severe. Historian D. D. Wallace remembered one student who painted Snyder's cow, which, unfortunately, led to the cow's death and the student's expulsion.

Along with the *Journal*, a literary magazine that began publication in 1889, students started two new publications: the *Bohemian*, the yearbook, started in 1908, and the *Old Gold and Black*, the college newspaper, which was first published in 1915. After World War I, ROTC became an important fixture on the campus throughout the mid-20th century, as a stipend provided vital funds for students who often had little spending money. Many students worked on campus, applying to be dining hall workers or dormitory janitors, as did a future chairman of the board of trustees in the 1920s. Several jobs, including campus mail carrier, were especially coveted.

The pictures in this chapter show how campus life evolved from the early 20th century to the outbreak of World War II, four decades of significant change in America. While the student body doubled in size and the student experience changed, much about Wofford remained the same.

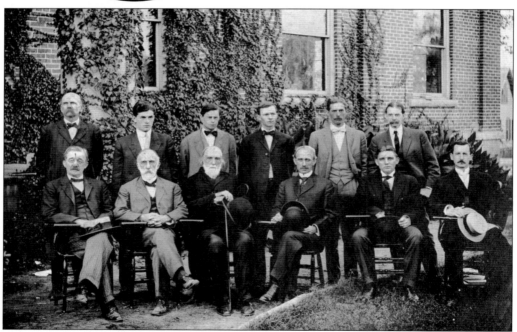

Henry Nelson Snyder sat for this portrait near the beginning of his 40-year presidency, the longest in the college's history. Many of Snyder's Vanderbilt instructors had Wofford connections, which is probably what led the young English professor to teach at Wofford in 1890. He studied for his doctorate in Germany, but his election as Wofford president in 1902 kept him from completing the degree.

Several of the faculty members in this 1908 portrait would serve with Snyder for decades. They are, from left to right, (first row) Daniel DuPré, sciences; J. A. Gamewell, Latin; James H. Carlisle, president emeritus; President Snyder; Coleman Waller, chemistry; and David Duncan Wallace, history; (second row) John G. Clinkscales, mathematics; A. R. Bressler, gymnasium; J. B. Peebles, mathematics; M. L. Spencer, English; A. B. Cooke, German and French; and A. G. Rembert, Greek.

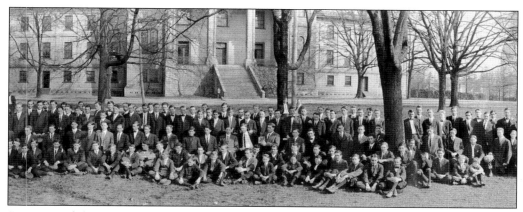

A portion of the 1912–1913 student body sits for this panoramic photograph in front of Main Building. Taken by a camera that turned on its tripod to capture a wider view, this is one of a handful of panoramic images in the archives from this time period. The student body in 1912 consisted of approximately 310 students.

Arthur Mason DuPré, a distant relative of Warren and Daniel DuPré, who preceded him on the faculty, was an 1895 Wofford graduate and headmaster of the Wofford Fitting School before moving to teach Latin in the college. Known as a fair, but strict disciplinarian, he was the dean from 1920 to 1940 and acting president in 1920–1921.

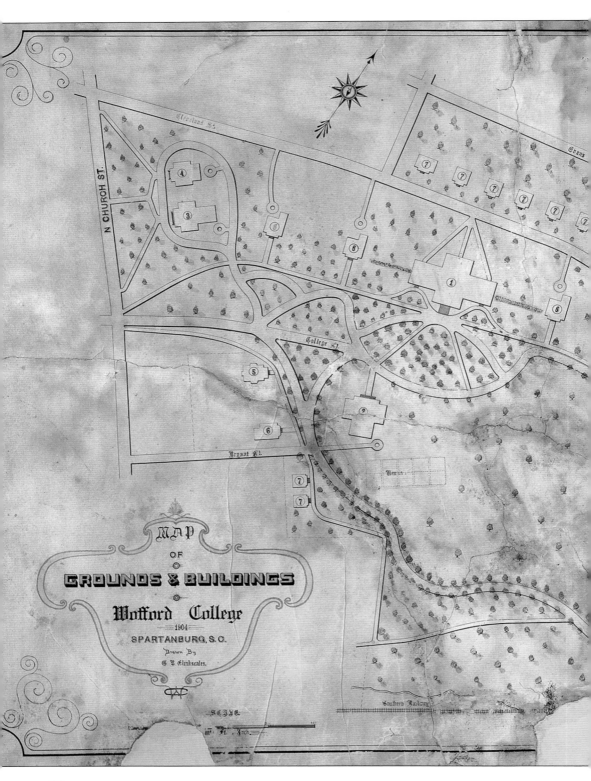

MAP

OF

GROUNDS & BUILDINGS

Wofford College
1904
SPARTANBURG, S.C.

Drawn By
G. L. Elmhscales.

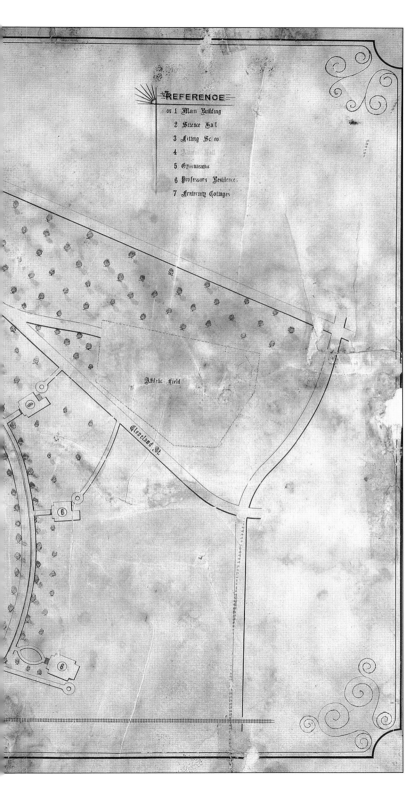

REFERENCE
or 1 Main Building
2 Science Hall
3 Fitting School
4
5 Gymnasium
6 Professors Residence
7 Fraternity Cottages

Athletic Field

Cleveland St.

This watercolor and ink drawing is of the campus as it appeared in 1904. It was prepared by George Clinkscales, who was a mathematician like his father, Prof. John G. Clinkscales. The drawing hangs in the college archives. The map shows a number of buildings that no longer exist, including the science building, a number of cottages, and two fitting school buildings.

39

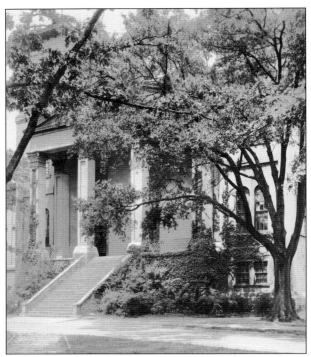

Main Building underwent renovations early in Snyder's tenure, but its outward appearance changed very little from when it was constructed. Inside, it was wired for electric lights, and steam heat replaced old fireplaces. This, it was noted, made the chapel much more comfortable in the winter, as the old stoves had not been able to keep it warm.

A gift from John Bomar Cleveland, class of 1869, the Cleveland Science Hall was only the college's second academic building. Cleveland told his classmate, Prof. Daniel DuPré, to supervise its construction and send him the bills. The final cost was never disclosed, but was reported to be more than $25,000. The building, with its remarkable dome that later housed a planetarium, remained in service until 1960.

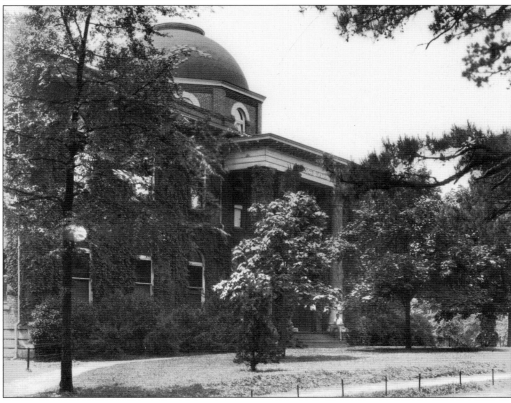

The college's original library was in Main Building, but in January 1910, with a $10,000 gift from the daughter of Prof. Whitefoord Smith and another $10,000 from the trustees, the college opened the new Whitefoord Smith Library. Expanded in the late 1940s, it remained in use until 1969. The front portion of the library was a large reading room, and President Snyder is pictured below (first row, third from left) meeting with a group of students in that room. The room to the rear housed bookshelves. After the Sandor Teszler Library was built in 1969, this building was renovated and renamed the Charles E. Daniel Building. It now houses offices and classrooms.

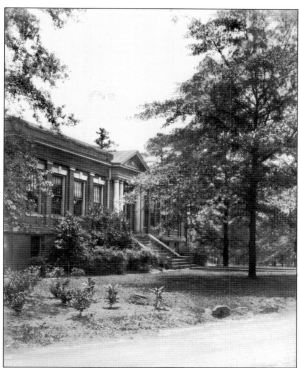

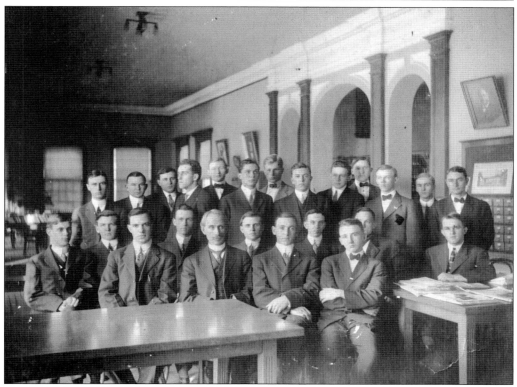

The first large dormitory was the James H. Carlisle Memorial Hall, which opened in September 1912. It was built at a cost of $50,000. With room for 160, it replaced a number of less expensive cottages that had housed students. Initially Carlisle Hall was primarily reserved for freshmen and sophomores, though all students ate in its dining room.

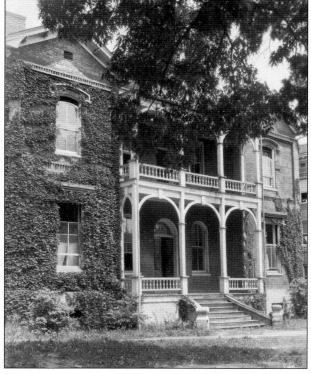

Alumni Hall, home of the Wofford Fitting School, was renamed Archer Hall after the top floors burned in 1901. The fitting school served as a preparatory school for the college in a day when good-quality public high schools were uncommon. Graduation from the fitting school qualified a student for admission to Wofford's freshman class without any further examinations.

Built to house the Wofford Fitting School after fire destroyed the top floors of Alumni Hall, this building was renamed Snyder Hall after the school closed in 1924. It became the college's second dormitory, though some rooms were oddly sized, having been classrooms. Snyder Hall was demolished in the early 1980s to make room for the Papadopoulos Building complex.

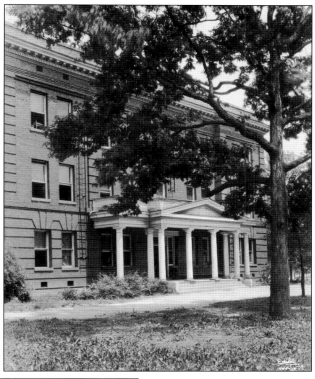

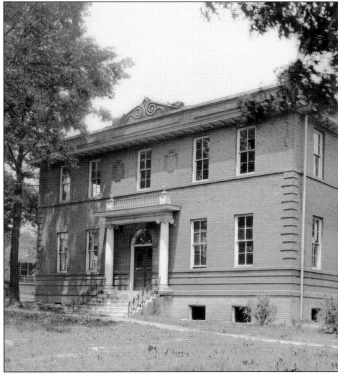

The fitting school needed more space than the older two buildings provided, so the college built a Recitation Hall for classroom space. It later became the ROTC Building before it was demolished to make way for the Papadopoulos building.

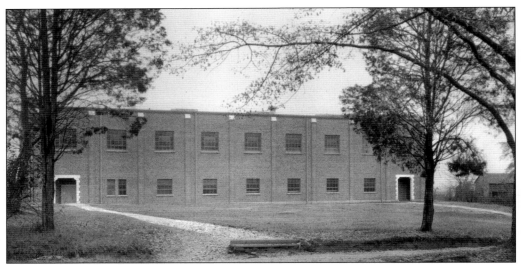

Built in 1929 at a cost of $41,000, met partially by a gift of $20,000 from Isaac Andrews, Andrews Field House was the Wofford basketball team's home court until 1980. It was expanded first in 1949 with a second gift from Andrews and again in the 1960s to include additional practice space and locker rooms.

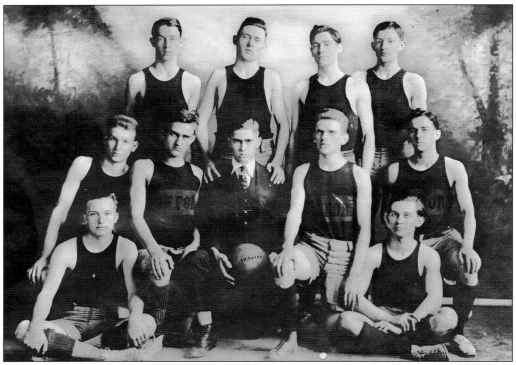

Basketball came to Wofford in the late 1890s, but a lack of inside playing space made winter games difficult. Before 1929, teams sometimes played at the city high school. This group, from 1916, finished the season with a record of 8-4, with two victories over the University of South Carolina (USC) and one over Clemson. Future professor R. A. Patterson (second row, second from right) was team captain.

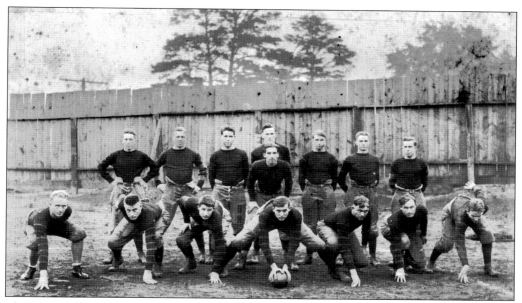

After several years of pleading by students and alumni alike, trustees restored intercollegiate football late in 1913, with play to resume in 1914. This team from 1915 achieved a 3-5 record. The first winning season after intercollegiate play resumed was in 1917.

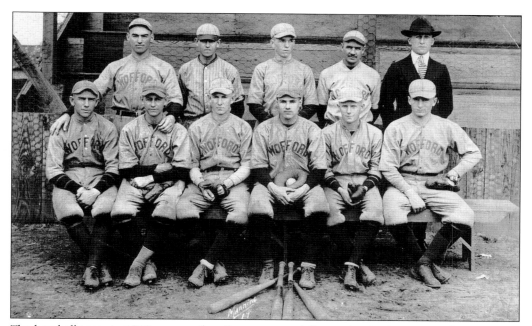

The baseball team in 1919 was another that was especially good, winning a state championship with a 1-0 victory over Furman. The team amassed a record of 15-3, all without the benefit of a coach. Two weeks after practice started, coach Frank Ellerbe signed a major league contract and left to join the Washington Senators.

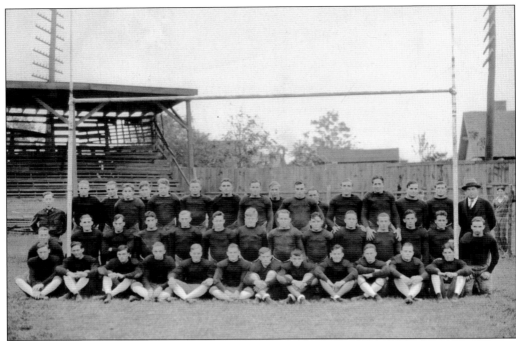

Tommy Scaffe coached the 1929 football team (above), which compiled a record of 3-5. It may have been what is now called a rebuilding year, as the team had more sophomores than juniors or seniors. The team is pictured in front of the old stands, though the college was in the process of rearranging the athletic fields and building new seating for the 1930 season. The three members of the 1929–1930 football team pictured below are, from left to right, sophomore end R. Carrol, junior tackle Henry Ross, and junior end John W. Speake. The yearbook staff used these photographs to make individual shots on the football pages.

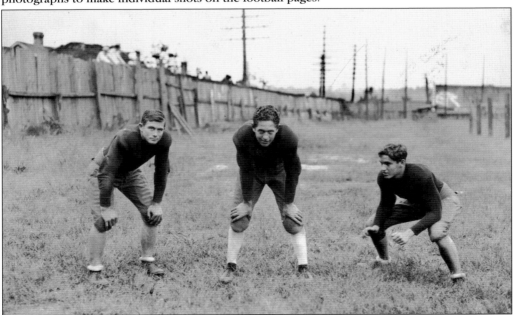

In this 1929–1930 cheerleading photograph are John A. May (left, class of 1931) of Aiken, chief cheerleader, and Tom K. Lawton (right, class of 1931) of Spartanburg, assistant cheerleader. Their duties were similar to those of cheerleaders today: lead the students in cheering at football and other athletic contests.

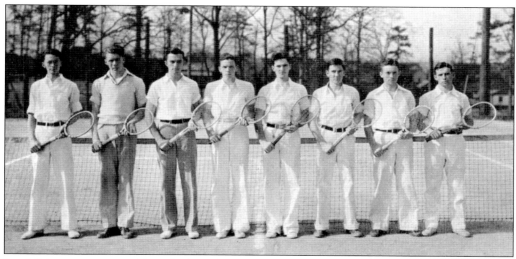

In addition to growing athletic facilities for basketball and football, the college had several tennis courts. The 1934 tennis team consists of (from left to right) Gerald DuBose, George Price, F. B. Bomar, W. C. Herbert, Herbert Hucks, R. M. Phillips, A. J. Strickland, and R. W. Thompson.

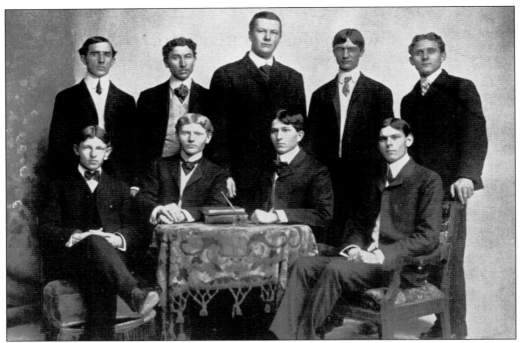

Founded in 1889 by the Calhoun and Preston literary societies, the *Journal* was primarily a literary magazine, but in the days before a campus newspaper or yearbook, it served those purposes as well. Students submitted fiction, poetry, and nonfiction essays, reviewed the contents of other college literary magazines, commented on campus and national news, and reported on alumni activities. This is the group that published the *Journal* in 1904.

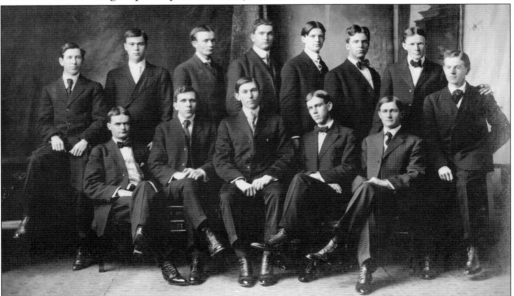

Beyond the debates that occurred in the literary societies, students from different classes debated, and a team sometimes traveled to other colleges. These are members of the 1908 debate team. Being selected was a high honor and required substantial knowledge and skill.

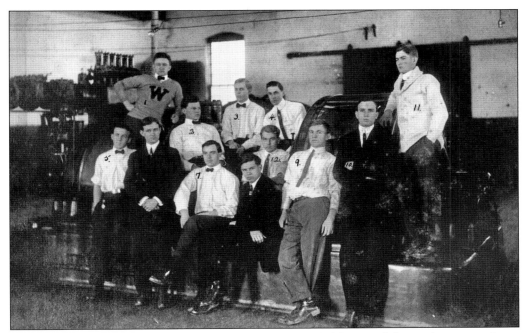

Student groups were not limited to literary societies and debating clubs. With a new science building, students had new resources to explore the sciences as well. This group is the Electrical Club, as they appeared in 1914 in one of the Cleveland Science Hall laboratories.

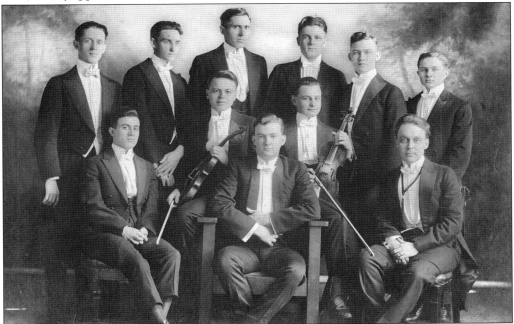

The 1917 Glee Club was an early musical group on campus. With no music major, performance has not generally been a central feature of campus life, but student musical groups have always existed. Glee Clubs often traveled to perform in churches and for civic groups around the state and region accompanied by a student manager, who set the schedules, and a director.

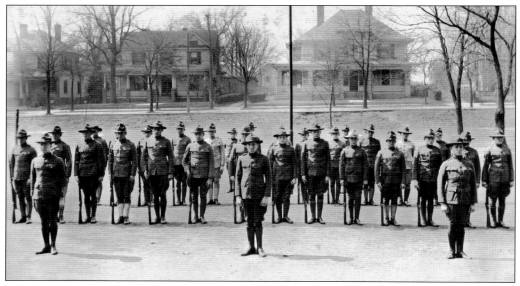

During World War I, the college and fitting school became virtual military camps. The government organized most of the students into the Student Army Training Corps, a precursor to ROTC. Studies were reorganized to meet military needs. This picture shows the fitting school's student body during the 1918–1919 school year.

With the advent of the Reserve Officers Training Corps (ROTC), student cadets had opportunities and obligations to undertake additional training. In this 1921 photograph, William C. Bowen (class of 1923, second from left) and Marvin M. Player (class of 1923, third from left) are attending ROTC summer camp at Fort Knox, Kentucky. The other two cadets are unidentified USC students.

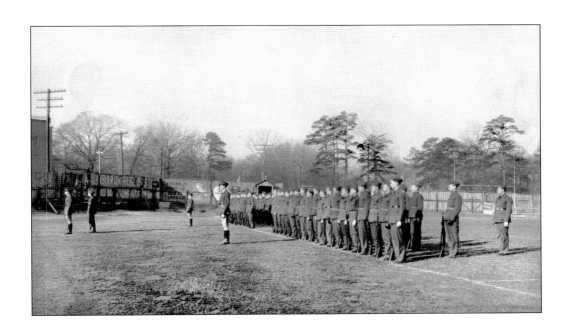

Students in the Wofford ROTC unit (above) pose on the parade ground—more accurately, one of the college athletic fields—in 1930. In that year, 70 percent of the student body was involved in ROTC. The ROTC band company (below) practices on the field. These photographs are part of a collection prepared for the *Bohemian* staff in 1930. Many of the images were published in the yearbook that year.

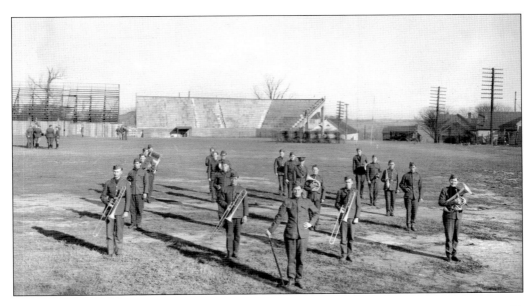

Prof. Arthur Galliard Rembert graduated from Wofford in 1884, and in 1887, he was named headmaster of the Wofford Fitting School. In 1893, he became professor of Greek in the college, a post he held until 1933. He was known as "Knotty" partly because he was tough as a knot, but also because he was a skinny fellow with wild hair that went in all directions.

Dr. William L. Pugh came to Wofford in 1911 as professor of English language and literature. An Iowa native, he held a doctorate from Harvard. He specialized in medieval literary works, but like everyone at the college in those days, he taught widely in the field of literature. Though he taught at Wofford for 36 years, he remained somewhat in the shadow of several more prominent English professors.

Dr. Coleman B. Waller was a member of Wofford's class of 1892 who went on to complete a doctorate in chemistry at Vanderbilt. After studying biology at Johns Hopkins for a year, he returned to the college in 1904 as professor of chemistry and biology. In 1911, he built a home on campus that in 1942 became the president's home. Waller served until 1947.

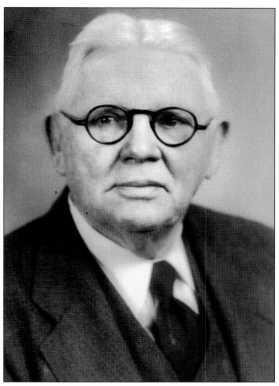

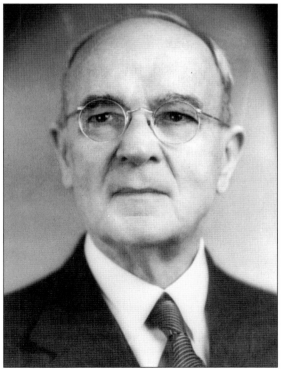

A Tennessee native and Vanderbilt graduate, Prof. Arcadius McSwain Trawick served as a Methodist minister and professor before coming to Wofford in 1921 as professor of religious education. In addition to his teaching, he wrote columns in the Methodist newspaper, and students remembered him as a fine scholar and a gracious campus host. He retired in 1947 but continued to teach at Spartanburg Junior College.

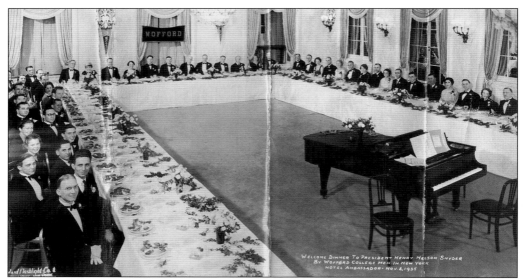

Wofford alumni in New York City gather in 1935 to hold a dinner in honor of President Snyder. Photographs such as this demonstrate how many Wofford graduates had moved to cities like New York in the first half of the 20th century.

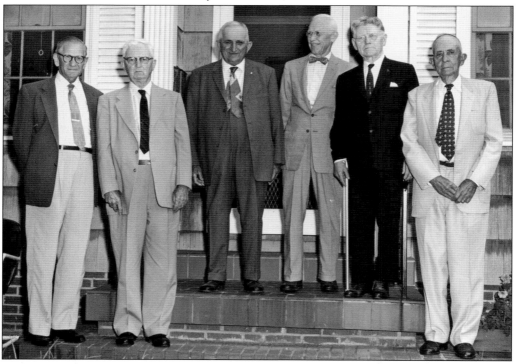

Graduates of the class of 1904 met in 1959 to celebrate the 55th anniversary of their graduation from Wofford. Alumni meetings were a regular fixture of commencement weekends for decades, with one day being reserved for class meetings such as this. Members from the class of 1904 are, from left to right, A. C. Daniel, Claude Goodlett, Haskell Shull, William C. Herbert, Simpson F. Cannon, and W. W. Niven.

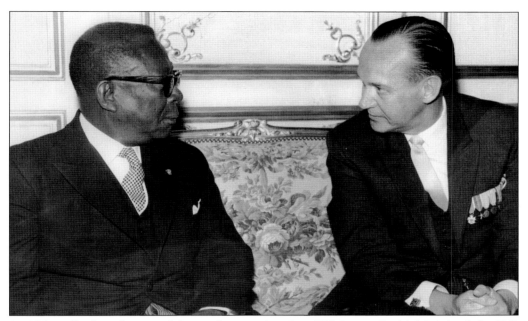

A 1935 Wofford graduate and Spartanburg native, Ben Hill Brown Jr. (right) joined the U.S. Foreign Service, serving diplomatic appointments and as an official in the State Department. As the U.S. ambassador to Liberia, he is pictured here with Liberian president William Vacanarat Shadrach Tubman.

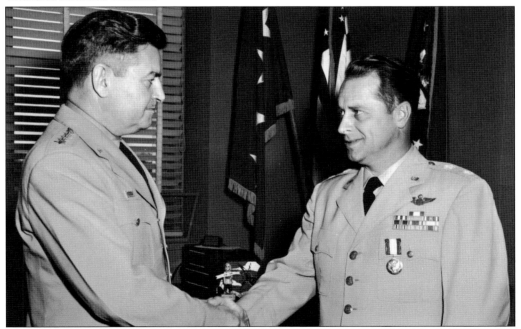

John Beverly Montgomery (right) graduated from Wofford in 1933. A native of Spartanburg, he served in the U.S. Army Air Corps during World War II. Promoted rapidly, he became a major general in the U.S. Air Force. He is pictured here with Gen. Curtis LeMay, on whose staff he served. A number of General Montgomery's photographs are in the archives collection.

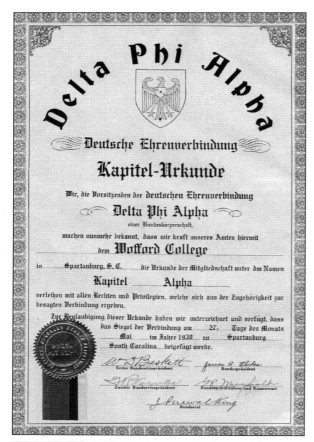

Prof. James A. Chiles, who taught German at Wofford for more than 30 years, organized the first German club on campus, Deutscher Verein, or German Society. It evolved into the honorary society Delta Phi Alpha. The Alpha chapter is still active at Wofford.

Necessitated by a larger student body in the early 1900s, the Carlisle Literary Society was the third literary society to form. The group requested to use President Carlisle's classroom as its meeting room and named itself in honor of the college's third president. This 1930 photograph shows the Carlisle members in the declining days of the societies.

The campus has always been characterized by an abundance of trees. As late as Snyder's early years in office, the grounds were so unlit "that even a resident might get lost at night in the darkness of pines," according to D. D. Wallace. This magnolia tree, located at the west end of Main Building, is already large in this 1930 photograph; it has continued to grow even larger.

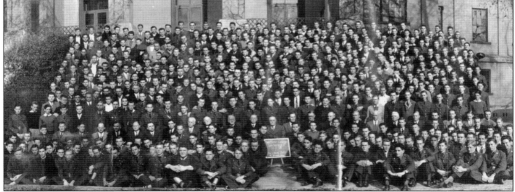

The student body of 1938–1939 sits for this portrait in front of Main Building in December 1938. The faculty, sitting together, has grown older and larger. Many of the nearly 500 students in the Depression era were in ROTC and are wearing their uniforms, which allowed them to save money on clothes.

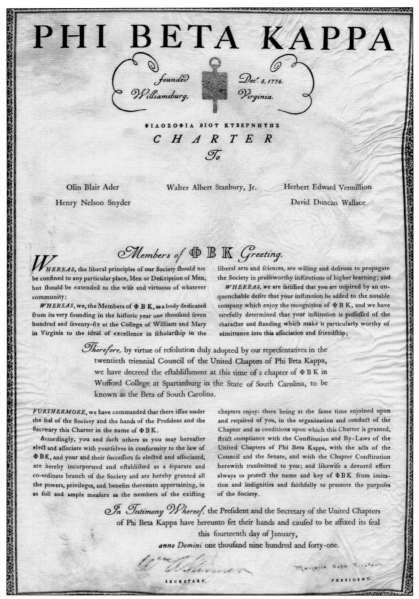

PHI BETA KAPPA

founded Williamsburg, *Dec. 5, 1776. Virginia.*

ΦΙΛΟΣΟΦΙΑ ΒΙΟΤ ΚΤΒΕΡΝΗΤΗΣ

CHARTER
To

Olin Blair Ader	Walter Albert Stanbury, Jr.	Herbert Edward Vermillion
Henry Nelson Snyder		David Duncan Wallace

Members of ΦΒΚ *Greeting.*

WHEREAS, the liberal principles of our Society should not be confined to any particular place, Men or Description of Men, but should be extended to the wise and virtuous of whatever community;

WHEREAS, we, the Members of ΦΒΚ, as a body dedicated from its very founding in the historic year one thousand seven hundred and seventy-six at the College of William and Mary in Virginia to the ideal of excellence in scholarship in the liberal arts and sciences, are willing and desirous to propagate the Society in praiseworthy institutions of higher learning; and

WHEREAS, we are satisfied that you are inspired by an unquenchable desire that your institution be added to the notable company which enjoy the recognition of ΦΒΚ, and we have carefully determined that your institution is possessed of the character and standing which make it particularly worthy of admittance into this association and friendship;

Therefore, by virtue of resolution duly adopted by our representatives in the twentieth triennial Council of the United Chapters of Phi Beta Kappa, we have decreed the establishment at this time of a chapter of ΦΒΚ in Wofford College at Spartanburg in the State of South Carolina, to be known as the Beta of South Carolina.

FURTHERMORE, we have commanded that there issue under the seal of the Society and the hands of the President and the Secretary this Charter in the name of ΦΒΚ.

Accordingly, you and such others as you may hereafter elect and associate with yourselves in conformity to the law of ΦΒΚ, and your and their successors so elected and associated, are hereby incorporated and established as a separate and co-ordinate branch of the Society and are hereby granted all the powers, privileges, and benefits thereunto appertaining, in as full and ample measure as the members of the existing chapters enjoy: there being at the same time enjoined upon and required of you, in the organization and conduct of the Chapter and as conditions upon which this Charter is granted, strict compliance with the Constitution and By-Laws of the United Chapters of Phi Beta Kappa, with the acts of the Council and the Senate, and with the Chapter Constitution herewith transmitted to you; and likewise a devoted effort always to protect the name and key of ΦΒΚ from imitation and indignities and faithfully to promote the purposes of the Society.

In Testimony Whereof, the President and the Secretary of the United Chapters of Phi Beta Kappa have hereunto set their hands and caused to be affixed its seal this fourteenth day of January, *anno Domini* one thousand nine hundred and forty-one.

SECRETARY.　　　　　　　　　　PRESIDENT.

The effort to obtain a chapter of Phi Beta Kappa, the nation's oldest scholarly honor society, began in 1930, when professors John West Harris (class of 1916), David Duncan Wallace (class of 1894), and Henry Nelson Snyder submitted a preliminary report on the college's qualifications. Harris, who founded the National Beta Club, had made the initial inquiry about Wofford being awarded a chapter. On January 14, 1941, Snyder's birthday, Dean Marjorie Hope Nicholson of Columbia University installed the Beta of South Carolina chapter of Phi Beta Kappa at Wofford. The charter, pictured here, was presented to five faculty members who had been elected to Phi Beta Kappa at other colleges—Snyder, Wallace, and professors Olin Ader, Albert Stanbury, and Herbert Vermillion. The installation of Phi Beta Kappa was the capstone of Snyder's presidency, as it recognized that the college had achieved a high level of academic quality. At the time, only one other college in the state, the University of South Carolina, had a chapter.

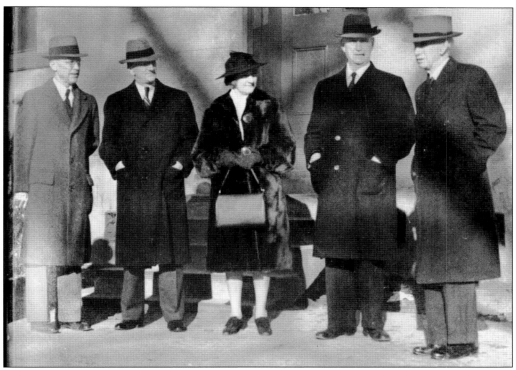

The college's administrative officers talk with each other in front of their offices in Main Building in the late 1930s. They are, from left to right, registrar William C. Herbert, treasurer Joseph K. Davis, librarian Mary Sydnor DuPré, Dean A. Mason DuPré, and President Snyder. DuPré served as college librarian from 1905 to 1953; Davis served as treasurer from 1920 to 1951.

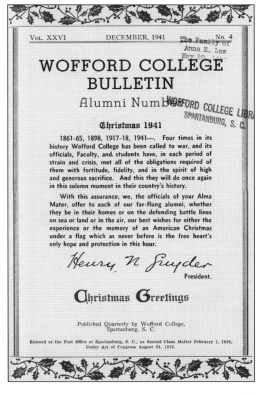

VOL. XXVI DECEMBER, 1941 No. 4

WOFFORD COLLEGE BULLETIN

Alumni Number

Christmas 1941

1861-65, 1898, 1917-18, 1941—. Four times in its history Wofford College has been called to war, and its officials, Faculty, and students have, in each period of strain and crisis, met all of the obligations required of them with fortitude, fidelity, and in the spirit of high and generous sacrifice. And this they will do once again in this solemn moment in their country's history.

With this assurance, we, the officials of your Alma Mater, offer to each of our far-flung alumni, whether they be in their homes or on the defending battle lines on sea or land or in the air, our best wishes for either the experience or the memory of an American Christmas under a flag which as never before is the free heart's only hope and protection in this hour.

Henry N. Snyder
President.

Christmas Greetings

Published Quarterly by Wofford College, Spartanburg, S. C.

Entered at the Post Office at Spartanburg, S. C., as Second Class Matter February 1, 1929, Under Act of Congress August 24, 1912.

"Four times in its history, Wofford College has been called to war," began the president's message to the college's alumni and friends in December 1941. The bulletin, which contained the college's news and academic regulations, served as a way of communicating with alumni. This message conveyed the college's wishes for "the experience or the memory of an American Christmas" to its far-flung alumni.

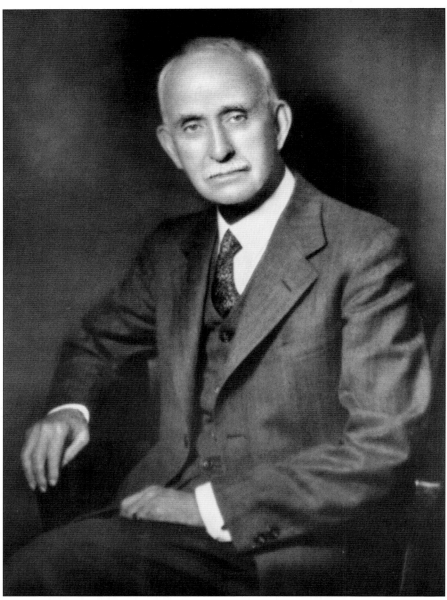

Henry Nelson Snyder was the college's first president who functioned as the chief executive rather than as the chairman of the faculty. He was an active leader in community, state, and national Methodist and educational circles. A frequent lay delegate to the Methodist General Conference, he was a member of the reunification commission that brought the three branches of Methodism together into the Methodist church in 1939. He also served on the church's hymnal commission, no doubt bringing his literary skills to help with that work. Snyder was also a much sought after speaker throughout the state and traveled frequently on behalf of the college. He described his life, work, and outlook on education in his autobiography, *An Educational Odyssey*, published in 1947. After his retirement, he continued to live on the campus, had a weekly radio show for a few years in the late 1940s, helped found the Spartanburg County Foundation, and remained active in civic affairs until his death in September 1949.

Three

WAR AND GROWTH
1942–1958

On the surface, Wofford did not appear to change much between 1942 and 1958. It remained a small liberal arts college with a homogeneous student body. Yet the school faced several challenges in those two decades and took a number of steps that would lead to greater changes in the 1960s. With most students in the military, the college was placed in a difficult financial position. The army used many small campuses around the country, including Wofford, as college training detachments to prepare future officers for various specialties, which helped the institutions cover their expenses. The army returned the Wofford campus to civilian control late in 1944, but only when the war ended did enrollment begin to rise. The student body grew almost overnight from a prewar number of 483, through a wartime trough of 96, to a record 720 in 1947. This sudden rise in matriculants challenged college leaders to launch a major campaign to raise funds for several new buildings. The Methodist conference chose this moment to reassert its influence, perhaps with the idea of consolidating all of its colleges on a new campus. This plan, which ultimately failed, halted plans for new construction.

The GI generation invaded Wofford beginning in 1946, and as in other parts of the country, these men were in a hurry to complete degrees and move on. These more mature students were often married, so the college provided married student or veteran's apartments for the first time. The older students passed through fairly quickly, and life at Wofford in the early 1950s became a routine of classes, fraternities, sports, and social activities. The faculty grew to meet the needs of a larger student body, and new faces joined the few professors who predated World War II. At the close of the 1950s, the college had a strong faculty ready to lead, a new trustee who was challenging the college to think bigger, the support of its alumni, and a continued commitment to developing well-educated alumni of character.

Walter Kirkland Greene became Wofford's fifth president in 1942. The only alumnus to become president, he was a baseball player on some of the strong teams of the early 1900s. After earning his master's degree at Vanderbilt and his Ph.D. at Harvard, Greene was a professor of English and dean of undergraduate studies at Duke University. He served at Wofford until 1951.

Dr. Clarence Clifford Norton came to Wofford as a professor of sociology in 1925 with a Ph.D. from the University of North Carolina. Named dean in 1942, he became dean of administration in 1949 when Wofford and Columbia College were put under joint administration. After Greene's retirement, Norton was acting president in the 1951–1952 term. He is best remembered for his annual dramatic reading of Charles Dickens's *A Christmas Carol*.

Dr. Charles E. Cauthen was a 1917 Wofford graduate who earned a doctorate in history at the University of North Carolina. He came to Wofford in 1942 after a number of years at Columbia College. He succeeded D. D. Wallace as chairman of the history department, carrying on the college's tradition of scholarship in South Carolina history.

Dr. Charles F. Nesbitt graduated from Wofford in 1922, took his seminary degree at Emory, and then earned a doctorate at the University of Chicago. He returned to Wofford in 1939 as a professor of religion, serving until he retired in 1966 and helping to train a generation of Methodist ministers in South Carolina.

The college's Church Street entrance gates were built in the late 1930s with a bequest from Thomas W. Smith of the class of 1871. It was given in honor of the donor's instructors and classmates. This photograph of the front entrance was taken in the early 1940s.

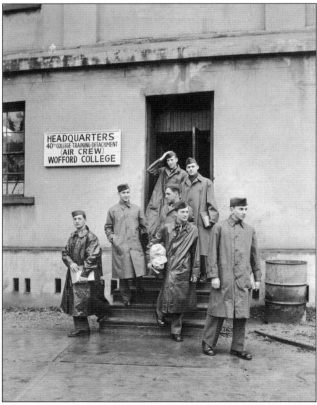

In February 1943, Wofford became a center for training aviation students for the U.S. Army's Air Corps, and some faculty were assigned to teach these students. Other faculty followed Wofford's students to Converse or Spartanburg Junior Colleges, where those who were not in the military attended classes.

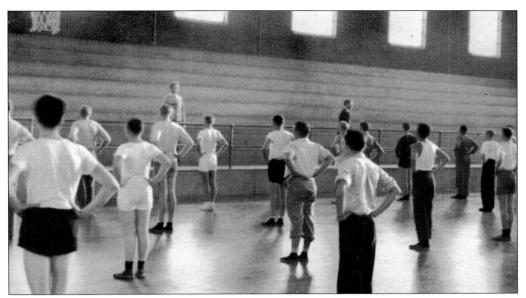

World War II brought changes to student life at the college even before the students had to move to one of the other colleges to continue coursework. Many students, the *Bohemian* noted, had friends or family members in the military and had only come back to college themselves as a way of better preparing for service. Students who were not in ROTC were required to report for physical training in Andrews Field House several times a week (above). When Spartanburg area farmers needed help with the cotton harvest in 1942, Wofford students and professors (below) reported to the fields to help.

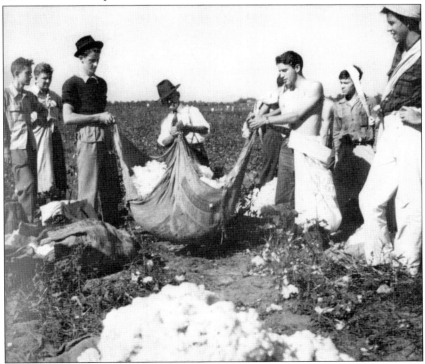

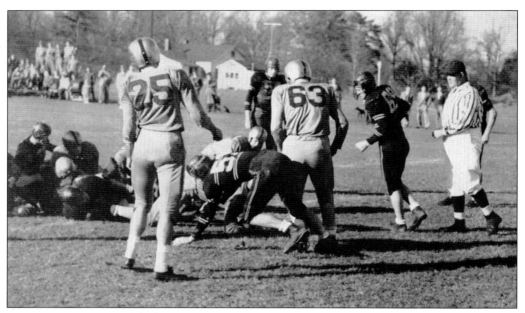

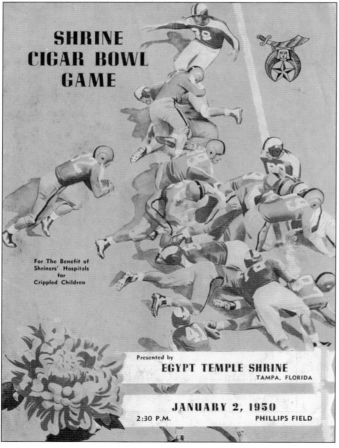

With the war over, many students wanted to relax and enjoy being students. Football became a major pursuit on campus in the late 1940s. Coach Phil Dickens and his teams put up several successful seasons from 1947 to 1952. In 1948, the team that "couldn't win for tying" started out with a national record five consecutive ties before winning its last four games. In the photograph above, the Terriers defeated Randolph-Macon in the final game of the season. The 1949 team posted an undefeated regular season record and received an invitation to the Shrine Cigar Bowl in Tampa, Florida. The Terriers lost to Florida State in that game in what was termed a mild upset.

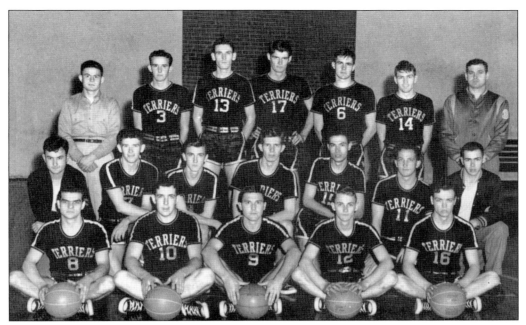

Joel Robertson (third row, far right) put up good numbers as the coach of the basketball team in the late 1940s and early 1950s. This 1948–1949 team posted a record of 11-8, and Robertson's two preceding teams both won at least 15 games each.

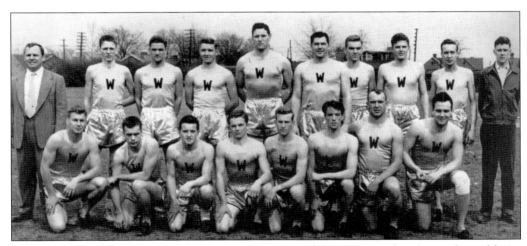

The track team poses in this 1949 photograph. Many of the runners played on other athletics teams as well. In addition to distance running, members of the team specialized in the shot put, pole vault, and hurdles. Willie Varner (second row, fifth from left) went on to a long career as a high school football coach in South Carolina.

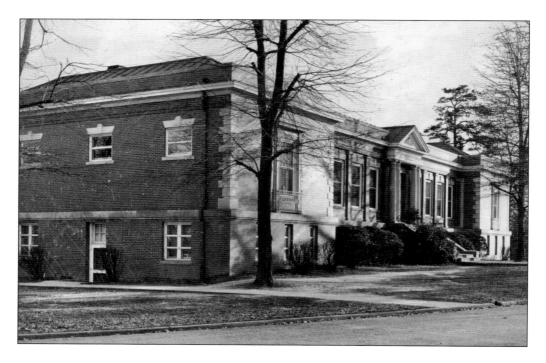

Part of Greene's "Wofford of To-Morrow" campaign was an expansion of the Whitefoord Smith Library (above), which had been in operation since 1910. As part of the project, two wings were added for additional stack space. This expansion kept the library in operation for 20 more years. The library was not the only building on campus that was not large enough for the growing student body. The Sam Orr Black Science Building (below), constructed behind Cleveland Science Hall in 1947, was expanded in 1953 with a gift from Dr. Sam O. Black and Dr. Hugh S. Black. The building has been used for a variety of purposes over the years, including as science classroom space and as the music and art building.

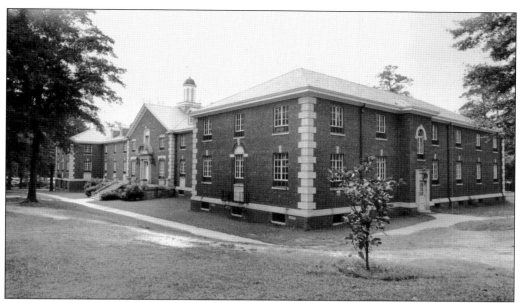

The first new residence hall constructed on campus in decades, Walter K. Greene Hall was built in 1950. Still in use today, it is the college's oldest residence hall and typically houses first-year students. A nice lobby with a fireplace provides a comfortable space for studying and lounging.

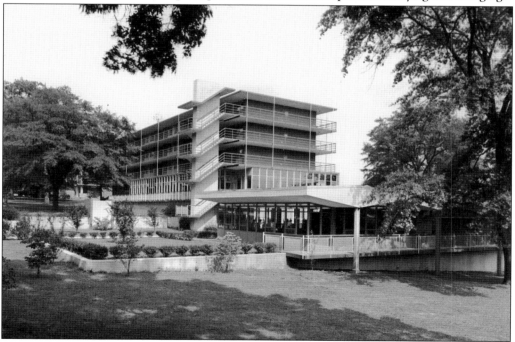

A model residential complex when it was built, Wightman Hall opened in 1958 with three floors of dorm rooms that opened onto exterior balconies. With a kitchen underneath, a dining room on the ground floor served the student body. A canteen and bookstore (foreground) were nearby. The dining hall was replaced in 1969 by the Burwell Center, and the residence hall itself was demolished in 1999.

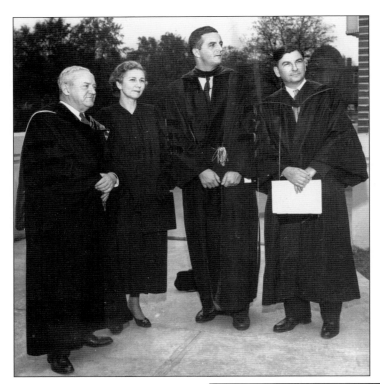

Elected the college's sixth president in 1952, Dr. Francis Pendleton Gaines Jr. was, at 33, the college's youngest president. Pictured here at his inauguration are, from left to right, his father, Francis P. Gaines, who was president of Washington and Lee; his mother, Sadie Robert Gaines; President Gaines; and his uncle, Dr. Joseph C. Robert, the president of Hampden-Sydney College. Gaines managed to get the board of trustees enlarged and recruited textile executive Roger Milliken to the board.

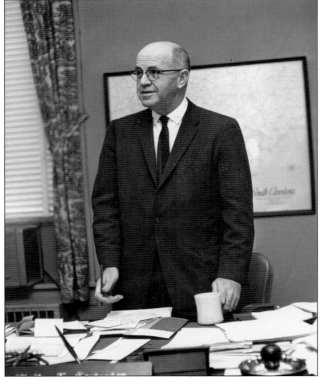

Named dean of the college in 1953, Philip S. Covington had first served as dean of students. As academic dean, he hired a number of professors in the 1950s and 1960s who formed the core of the faculty until the 1990s. His founder's day addresses were the stuff of legend, and he was regarded as a creative and unusual thinker.

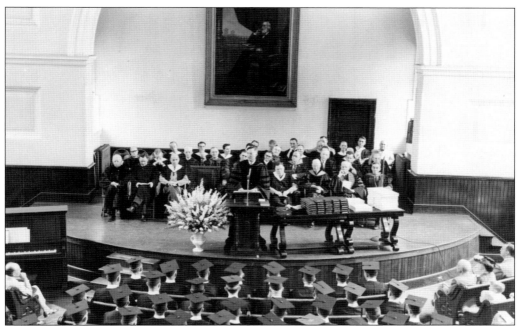

This image shows Wofford's 1952 commencement ceremony in Leonard Auditorium. In 1960–1961, the auditorium would be renovated and its appearance changed forever. At that time, the auditorium was no longer large enough to hold graduation, and it was moved to other locations.

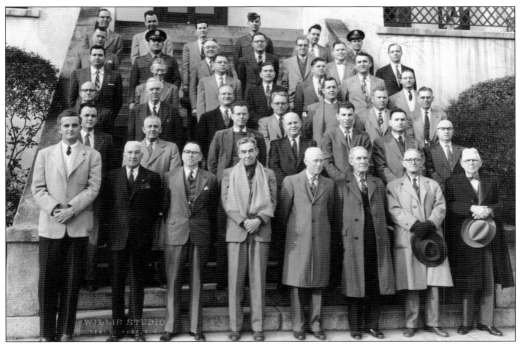

In what has become something of an annual tradition, the 1954 faculty gathers for this photograph on the front steps of Main Building.

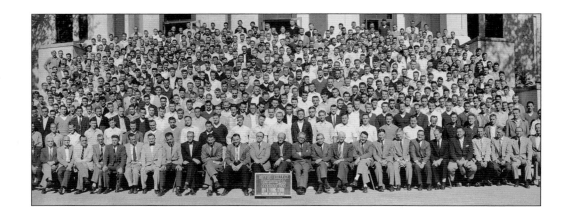

The student body and faculty (above) pose for this photograph in October 1955, with the faculty sitting in the first row. Reflecting the college's growth over the years, both groups are much larger than those in earlier such photographs, from 1938 (page 57) and 1900 (page 23). Faculty and invited guests (below) march from the campus to Spartanburg Memorial Auditorium for President Gaines's inauguration in the fall of 1952. For 30 years, from the late 1960s to the late 1990s, faculty and seniors made this annual march to the college's commencement exercises.

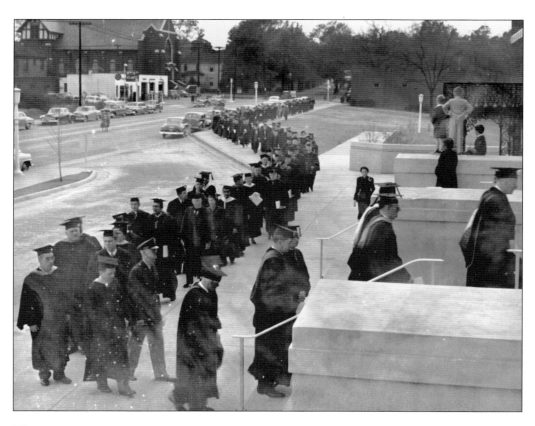

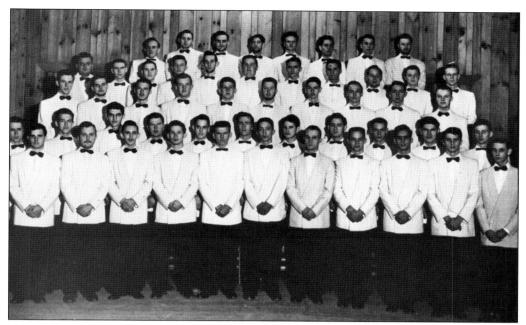

The Wofford Glee Club, under the direction of Prof. Samuel R. Moyer, was a cherished college institution during the 1950s. Its performances usually included a mixture of sacred and secular tunes. The club performed in churches and schools all around South Carolina, and each spring went on a longer tour out of state. Moyer, regarded as a showman as well as a mentor to many of his singers, ended concerts with the line: "Go to the church of your choice, but send your sons to Wofford!" In 1954, the Glee Club recorded an album, with songs such as "Do Not Forsake Me" from *High Noon*, "The Song of the Jolly Roger," "The Creation," and, of course, Wofford's alma mater. In years since, "Moyer's Men" have held several reunions.

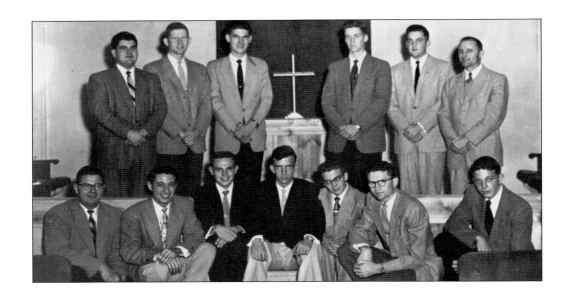

Religion remained a central part of student life at the Methodist-related college. Chapel attendance twice a week was still mandatory in the 1950s, and significant numbers of students went on to seminary and careers in the Methodist ministry. Students in all denominations were part of the Student Christian Association, and that group was responsible for various programs and worship services during the year. The Student Christian Association Cabinet (above) guided that organization. The Methodist Student Movement (below) met weekly at Central Methodist Church and consisted of students from Wofford and Converse.

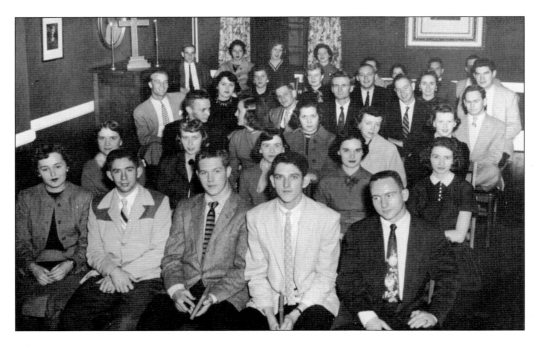

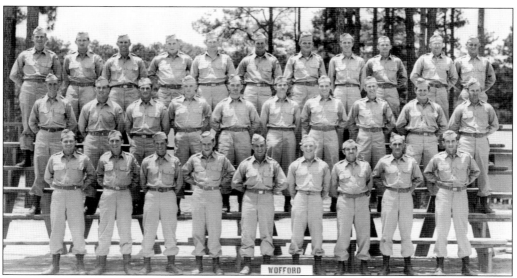

Throughout the cold war era, ROTC remained popular with Wofford students. In addition to lectures and military science labs on campus, cadets attended various summer camps. This group is at camp in 1952.

The college first constructed fraternity row in 1955–1956 to house the seven Greek-letter organizations. Each house has a living room, kitchen, chapter room, one bedroom, one bathroom, and a porch. The fraternities had no houses on campus before the 1950s.

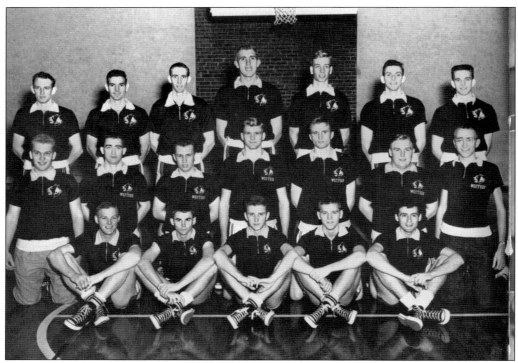

The early 1950s saw several Wofford basketball teams with winning seasons. This 1952–1953 team achieved a 14-9 record. Led by James Ellerbe "Daddy" Neal (third row, fourth from left), one of the strongest players not just on the team, but in the nation, the Terriers scored more than 100 points three times.

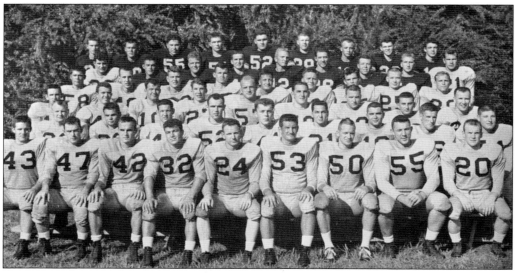

This 1956 football team completed the season with a 7-3 record, losing the opener to South Carolina but winning games against Furman, the Citadel, and Davidson. Head coach Conley Snidow, who had succeeded Phil Dickens in 1953, compiled a 77-59 record in 14 seasons.

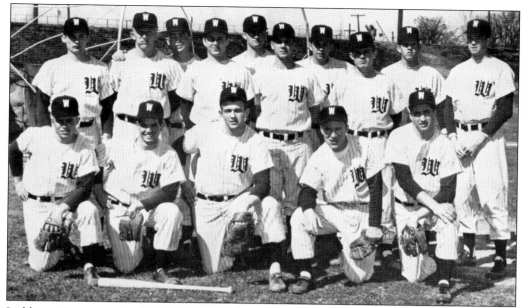

Led by senior cocaptains Walter Sessoms (third row, third from left) and Russell King (first row, third from left), the 1956 Terriers amassed a 14-4 record, the best in several years, and got the student body very interested in baseball, according to newspaper accounts at the end of the season.

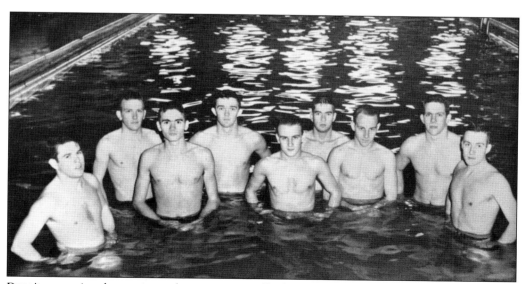

Despite occasional rumors to the contrary, Wofford has never had a campus swimming pool. Construction of a pool was part of the "Wofford of To-Morrow" plan, but funds never materialized. Lack of a pool, however, did not keep the Terrier Tankmen from competing. Pictured here in 1955, the swim team practiced at Spartanburg's YMCA.

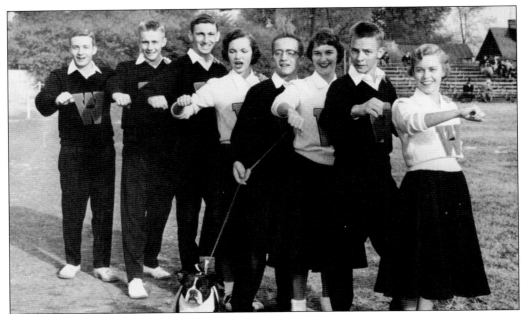

The 1955 cheerleaders included Wofford students as well as students from other colleges. Their job was much as it had always been: leading student cheers and promoting school spirit at athletic events. They included, from left to right, Bill Penny, David Lane, Alva "Tunky" Woodham, Julie Henderson, Bob Penny, Ann Ward, William "Diddy" Carlson, and Harriet Mahaffey.

With increased numbers of veteran students came increased numbers of married students. In 1946, with the help of the wives of the faculty, the wives of Wofford's students organized a group called the Wofford Dames. They held regular meetings, sponsored social activities, and tried to act as a support group for the young families on campus.

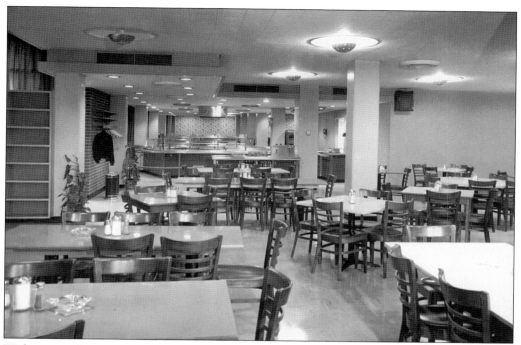

Wightman Hall's dining room was the student dining room from the late 1950s to the late 1960s. In the mid-1960s, it was the scene of occasional food fights, generally caused by student annoyance with repetitive menus and tough meat. Sometimes the fight spread to the Wightman balconies.

Wofford's canteen during the 1950s and 1960s, affectionately called the Dog Pound, or sometimes, because of its odd roof, the boathouse, is pictured here on a snowy night.

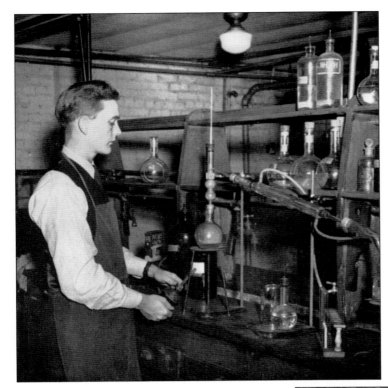

Dr. William P. Cavin, a 1945 Wofford graduate, is pictured here in one of the Cleveland Science Hall chemistry labs. In 1946, a year after graduating, he earned a master's degree at Duke and was back at Wofford teaching chemistry at age 21. He later claimed to be the youngest instructor in the college's history. Cavin retired as the department chair in 1987.

A member of the class of 1952, Dr. George D. Fields has been a Methodist minister, president of Spartanburg Methodist College, and, as assistant chief of chaplains, a brigadier general in the army. He has worked to preserve numerous Revolutionary War battlefields in the Southeast.

A popular and long-serving high school coach in South Carolina, Willie Varner was a 1952 Wofford graduate. In 43 years at Woodruff High School, he had a 383-132-10 record and 10 state titles. In 1994, he was inducted into the National High School Sports Hall of Fame.

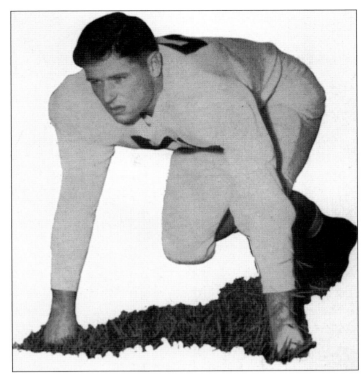

Publisher of his hometown paper in Bennettsville, South Carolina, William L. Kinney Jr. graduated from Wofford in 1954. As a student, he was editor of the *Bohemian*, president of the student body, and a member of the Senior Order of Gnomes. Kinney has been an active historic preservationist, serving on the state archives and history commission.

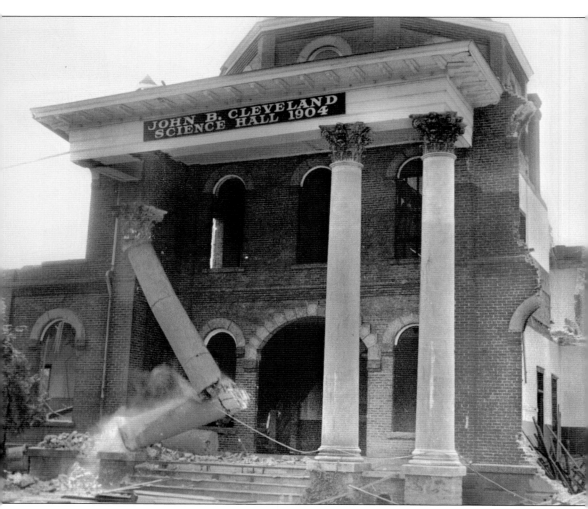

By the late 1950s, Cleveland Science Hall had become inadequate. Wofford, like much of the rest of the country, had developed a new focus on the sciences as the country entered the nuclear age. The building, which had served for more than 50 years, was demolished to make way for a more modern facility. Demolition of the science building represented a turning point in the life of the college. Wofford had struggled somewhat during the preceding decades, and a series of challenges—the war, enrollment growth, and church politics—had hindered developments. Positive developments were occurring, however. A number of newer professors had come to campus since the war, the college had started to modernize its aging physical plant, and administrators were beginning to look for more financial resources. Indeed, just as Cleveland Science Hall gave way to Milliken Science Hall, some of the days of making do with limited resources were beginning to pass away.

Four

AN OASIS OF TRANQUILITY
1958–1972

During the 1960s and early 1970s, a series of substantial changes transformed Wofford in ways that faculty and alumni of earlier generations could scarcely have imagined. The very nature of student life and the composition of the student body changed dramatically between the early 1960s and the mid-1970s. In May 1964, trustees voted to admit any qualified student regardless of race, and that September, Wofford's first African American student enrolled. In 1971, the college began to admit women as day students, paving the way for full residential coeducation in 1976. Student life became less regulated: the college ended a ban on alcohol in private dorm rooms; mandatory chapel ended; and a new student conduct code went into effect.

On top of that, a group of young professors came to succeed a large number of retirees, and many faculty members who had arrived just after World War II themselves assumed leadership roles. They brought curricular change to the college, creating a new January term called Interim that has become one of the hallmarks of the Wofford experience. New faculty also elevated the role of the arts on campus, creating opportunities for students to participate in theater, learn art history, and perform in musical groups. A new interdisciplinary course in values and issues was developed and remains required of every freshman.

The college's physical appearance changed as well. Along with a new science building, the century-old Main Building was completely renovated. Three new residence halls were opened, and the college constructed a new library and a new dining center, expanded the field house, and turned the old library into a classroom building.

Even with these changes, some things remained constant. The 1960s came to Wofford fairly late, and though great social movements affected the intellectual life, students did not protest too much. Social life continued to revolve around athletics, fraternities, and all of the things that college students everywhere cared about.

Wofford's seventh president, Dr. Charles Franklin Marsh, came to Wofford from William and Mary in 1958. An active Methodist layman, an economist, and a longtime educational leader, Marsh brought nearly 30 years of experience in higher education to Wofford. In his 10 years as president, he presided over desegregation, the creation of Interim, and the planning, renovation, or construction of eight buildings.

A Phi Beta Kappa graduate of the class of 1941, S. Frank Logan returned to the college in 1947 as registrar. An enthusiastic supporter of students and a man who sincerely loved the college, he served 13 years as dean of students, from 1956 to 1969. Students had strong feelings about Logan, who also directed the admissions office and worked in development.

Under the Wofford College charter, the board of trustees is responsible for governance of the college. In the fall of 1963, this board consisted of 21 members: 10 Methodist ministers and 11 lay members. After studying the issue for nearly a year, the board in this picture voted in May 1964 to admit all qualified students regardless of race.

Members of the college's secretarial staff met in the Sandor Teszler Library for this photograph during the 1970–1971 school year. Many of these staff members had worked at the college for years, and a few are still working at Wofford as of 2010.

Prof. Kenneth D. Coates came to Wofford in 1928 to teach in the English department. He advised many of the student publications and dabbled in journalism. During World War II, he filled in as an editor at the *Spartanburg Journal*. After his death in 1974, his brother Albert Coates compiled a book about him entitled *My Brother, Kenneth*.

Prof. John Quitman Hill graduated from Wofford in 1947, earning a Rhodes scholarship the next year. He returned to Wofford in 1953 as professor of mathematics, a post he held until 1972. Students claimed that "everything looks easy when he explains it," which is quite a compliment for a mathematician.

Prof. Raymond A. Patterson graduated from Wofford in 1916, taking a master's degree the next year. After graduate study, he returned to the college in 1921 to teach biology and chemistry, serving until his retirement in 1966. In addition to his campus duties, he served as a consultant to the Spartanburg Water System

Dr. John W. Harrington came to Wofford in 1963 to teach geology, a position he held until 1981. His books, *To See a World* and *Dance of the Continents: Adventures with Rocks and Time*, were both influential to generations of his students.

After a century of heavy use—half of this as the only college building—Main Building was long overdue for a renovation. During the 1960–1961 school year, the interior was almost completely rebuilt while preserving the original exterior walls. Rooms, hallways, and offices were reconfigured, and a steel and concrete framework replaced a decaying wooden structure. The building did lose some of its charm, but the renovation no doubt saved it for continued use. The auditorium was also renovated and enlarged somewhat, because the stage wall collapsed during construction, which gave the college the option of enlarging that end of the building. These pictures show Leonard Auditorium during renovation (above) and after the renovation was complete (below).

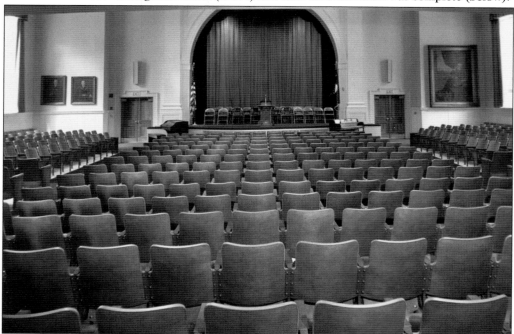

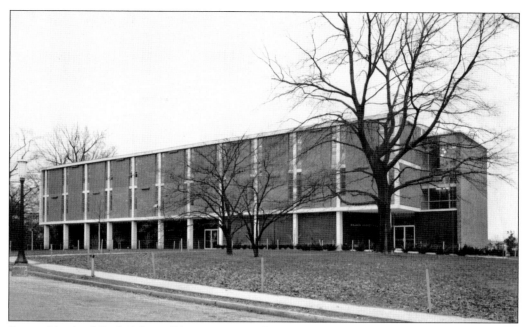

Opened in the fall of 1961, Milliken Science Hall replaced the outdated Cleveland Science Hall. With a large teaching amphitheater and modern labs and equipment, the new science building was designed to provide a superior education for future physicians and research scientists. It was named in honor of trustee Roger Milliken, the lead donor and driving force behind the project.

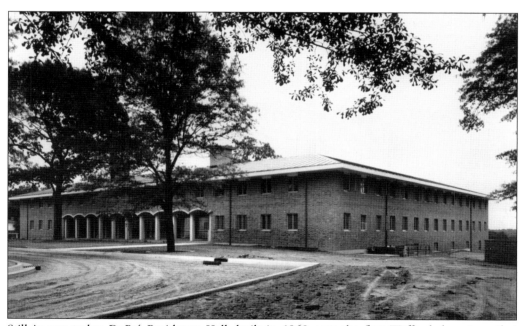

Still in use today, DuPré Residence Hall, built in 1962, was the first Wofford dormitory that included private sleeping rooms. Two students shared a sitting room, and each had a small space with a bed and a desk. DuPré became a popular residence for junior and senior men.

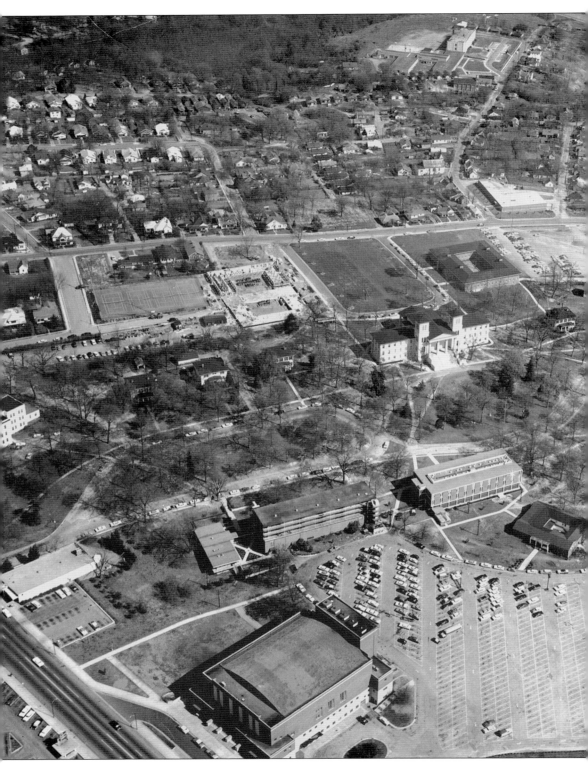

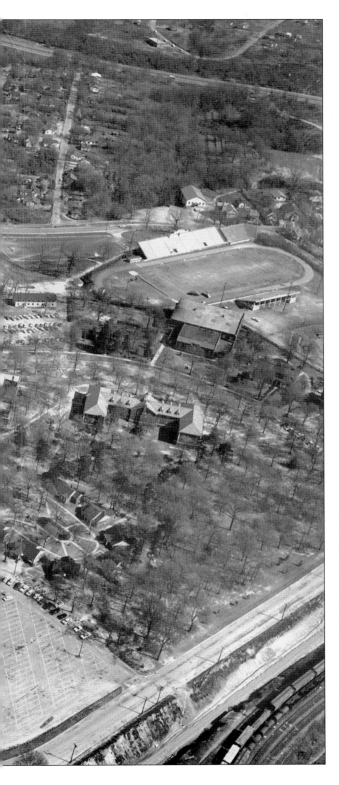

This aerial photograph of campus was taken in the winter of 1962–1963. Shipp Hall is under construction just above and to the left of Main Building. The newly constructed DuPré Hall is above and to the right of Main. In the foreground, near Spartanburg Memorial Auditorium, are the relatively new Wightman Residence Hall and Milliken Science Hall. The aging Snyder Hall is on the left edge of the picture, just left of the row of homes. The aerial view also shows the neighborhood on the north side of Evins Street, as well as a considerable amount of space on campus to be filled with new buildings in the next decades.

91

Shipp Residence Hall (above) opened in the fall of 1963 across the lawn from DuPré. Shipp's room arrangement (left) mirrors that of DuPré, with two students sharing a sitting room and each having a private room, or cube, as students called them, for sleeping and studying. Shipp also has a large central lounge that is a popular place for meetings and events.

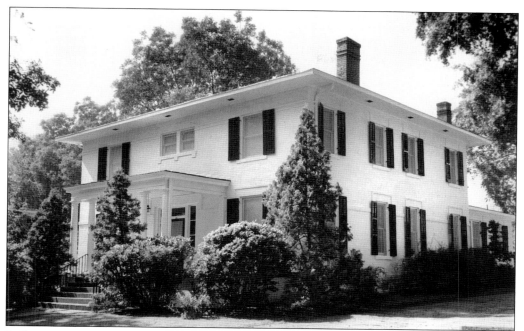

Built in 1911, the President's Home was originally the home of Dr. Coleman B. Waller, a chemist. In 1942, the college acquired the structure and made it into a home for Walter K. Greene. It has been the president's home ever since. The house underwent minor renovations before Marsh moved into the house in 1958 and extensive renovations before President Dunlap occupied it in 2000.

The Hugh S. Black Building, once named Archer Hall in honor of its major donor, was renamed following a 1940s renovation. Upon learning of a planned visit by the Archer family, perplexed administrators gathered to find a solution, and according to legend, Dean Philip Covington looked out a window and announced, "Gentlemen, I believe I see Archer Circle!" This is a snowy Archer Circle.

Coach Conley Snidow continued to lead the Terriers until 1966, when his assistant, James Brakefield, succeeded him. Brakefield led several good squads, including this 1969 team (above), which won nine games in a row after losing the first two. Quarterback Harold Chandler is holding for kicker Randy Bringman (below) in this photograph most likely taken in 1969.

Coach Gene Alexander led the Terriers for 19 seasons, compiling 283 wins and 265 losses. His 1960 team, with a 25-6 record, won an invitation to the NAIA national tournament in Kansas City, where they made it to the quarterfinals. The 1965 team (above) recorded an impressive 22-8 record. Pictured at right in action against Newberry College, the 1971–1972 team featured players such as Mike Trigg (shooting), Doug Murray (No. 50), and Fred Pearson (No. 22). Trigg was named to the NAIA District 6 all-district second team.

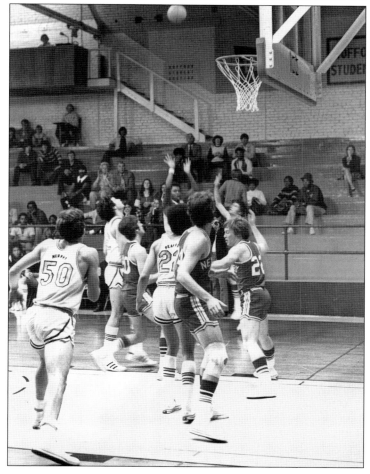

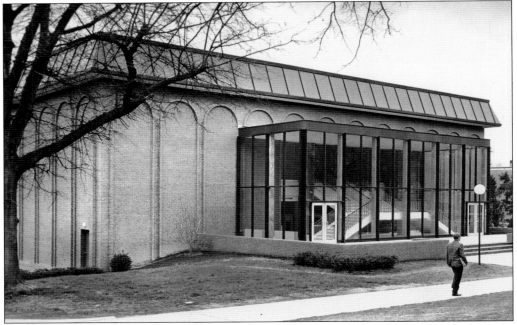

The college's dining room in Wightman Hall soon proved to be too small, and in 1969, the Burwell Campus Center opened with a new dining hall. On the ground floor, two large and several smaller meeting rooms offered additional dining space. The post office and other campus offices are located in this building.

Named in honor of Charles Franklin Marsh, this residence hall has primarily housed freshman and sophomore men since it opened in 1969. In its early days, some campus offices were located on the ground floor.

Students began to lobby in the mid-1960s for a new library, and Frank J. Anderson was appointed librarian in 1966 with the charge of building a new facility to replace the aging and inadequate Whitefoord Smith Library. A new library (above and below) opened in August 1969 and won architectural design awards. In 1971, it was named in honor of Sandor Teszler, a native of Hungary and a Holocaust survivor who came to the Spartanburg area after World War II to start a textile manufacturing company. The facility has about three times as much space as the old one and houses a gallery, a conference room, and the college archives. Though libraries have transformed in the last 40 years, the Sandor Teszler Library has been able to adapt to the changes.

Paul Hardin III became Wofford's eighth president in September 1968 and brought new energy and a sense of activism to the campus. An attorney, Hardin came to Wofford from Duke University, where he had been a law professor. In his four years as president, he removed some of the administrative controls over student life, pressed for increasing minority enrollment, and began moving toward coeducation.

Named dean of students in 1969, Donald J. Welch served in that position until 1973, when he became campus minister and counselor. As dean, he believed that "students should have the right to style their own lives." As chaplain, he worked with students as a counselor and a teacher, presenting thoughtful and sometimes challenging messages to the campus. He left in 1980 to become president of Scarritt College.

A group of early-1970s faculty recreates a portrait of the faculty in the early 1870s (see page 16). The reenactors are, from left to right, Clyde Anglin, philosophy; Philip Racine, history; Dan Maultsby, sociology; Donald Schwab, chemistry; Edmund Henry, English; and James Bruce, sociology.

While women had attended Wofford off and on through the 20th century, they had only attended as regular students from 1897 to 1904. In February 1971, the college began to admit women as regular students, though without providing campus housing for them. In 1975, trustees approved full residential coeducation. The Association of Wofford Women sits for this photograph, taken in 1975.

Implemented in January 1968, Interim has become a fixture at Wofford. Students and faculty take an in-depth look at a specific subject during the four-week term. Students here are working with librarian Frank Anderson on a book-printing project using the library's press.

Whether during Interim or in regular term courses, professors work closely with students on assignments. Dr. Donald Dobbs, professor of biology from 1955 to 1995, explains a concept to one of his students. For these 40 years, nearly every Wofford graduate who became a physician got his or her start in Dobbs's introductory biology course.

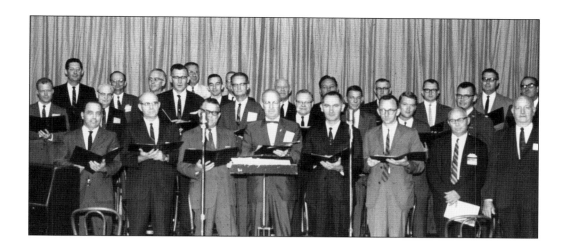

Alumni have continued to stay connected to Wofford. These Glee Club alumni (above) gathered in 1966 for a reunion concert. They represented classes from the 1930s, 1940s, and 1950s. Wofford alumni have been successful in many professions, including law. In 2002, three Wofford alumni served together on the South Carolina Supreme Court. At the commencement that year, each received an honorary doctor of laws degree. Pictured below are, from left to right, trustee chairman Russell King, Justice Costa Pleicones (class of 1965), Justice John Waller (class of 1959), Justice E. C. Burnett (class of 1964), and Pres. Benjamin Dunlap.

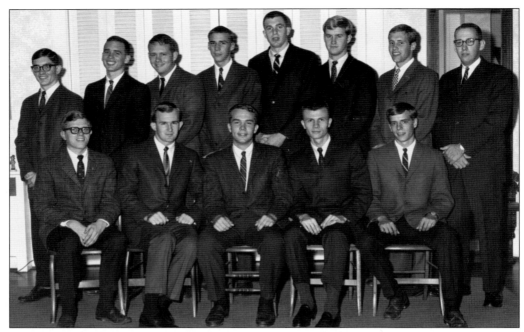

The precursor of the current Wofford Scholars program, the King Teen Program was a contest held annually in which high schools nominated candidates to come to Wofford to compete for scholarships. A generation of Wofford students had to live with the dubious honor of having been a King Teen. The group from the mid-1960s sits for this photograph, taken in 1965.

Wofford's student publications continued to operate in the late 1960s, and in fact, student journalists helped agitate for some reforms. They often asked difficult questions of administrators. The *Journal* staff poses above in 1971. Wofford students began to look a little different by the late 1960s.

Students play pool in the college canteen in the early 1970s. After the Burwell Building opened in 1969, the old dining area in Wightman Hall was renovated for use as a canteen.

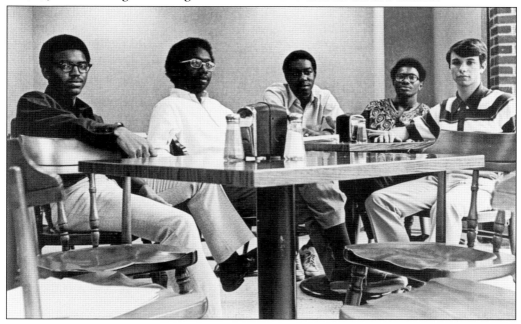

Campus Union and its assembly and system of committees replaced the old student government association and its senate during Paul Hardin's presidency. Many Campus Union duties were carried out through committees, such as social affairs, facility affairs, campus relations, and civic affairs. Members of the 1971 civic affairs committee include, from left to right, Bernard Leach, James Cheek, Franklin Smith, David Whitmire, and Sam Powell.

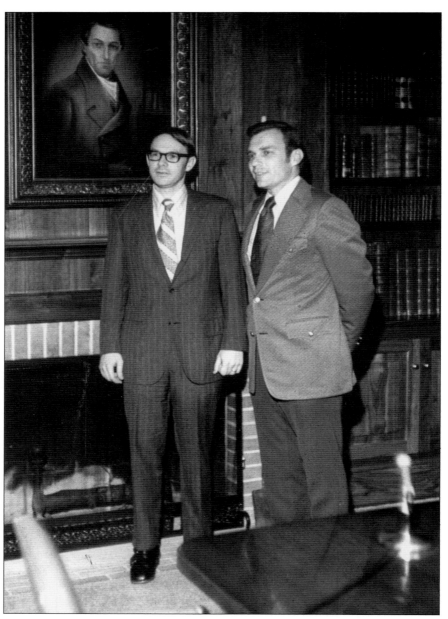

Paul Hardin's presidency lasted only four years, though they were years of constant activity. By making students more responsible for the conduct of student life, government, and discipline, and allowing them to follow state law regarding alcohol possession and consumption, Hardin ruffled some feathers with Wofford's church constituents. He had some notable successes in his short term: he helped implement meaningful desegregation, hired the first African American administrator in Bob Leach, and helped create an open speakers policy for the college. In April 1972, Hardin accepted an appointment as president of Southern Methodist University and submitted his resignation. Trustees quickly turned to the man who had been Hardin's academic dean, Dr. Joab M. Lesesne Jr. Lesesne's election as Wofford's ninth president meant that he merely moved his office across the hall, effecting a smooth transition between administrations.

Five

INNOVATION AND TRADITION
1972–2010

The last 40 years at Wofford have seen continued growth in the college's enrollment, diversity of the student body, and physical facilities. When he took office in 1972, one of Dr. Joab M. Lesesne's first tasks was to reconcile some of the college's constituencies to the significant changes that had taken place during the Hardin administration. He also had to move forward on admitting women as resident students, which was approved in October 1975. Even though the college had opened several new buildings just before he took office, Lesesne's administration raised funds to upgrade a number of facilities. The Campus Life Building gave the college something it had not had before—a student center. In the 1990s, Wofford added new residence halls and a new high-tech teaching building. Moreover, the move from NAIA to NCAA Division II athletics in 1988, then to NCAA Division I in 1995, occurred alongside a transformation in the college's sports facilities.

Growth continued under Dr. Benjamin Bernard Dunlap's presidency, which began in 2000. The renovation of Main Building and the construction of the Roger Milliken Science Center enhanced the college's teaching spaces, and the new Wofford Village apartments for seniors marked a significant move toward improving student life. Though most students still come from the Southeast, the college has expanded the geographic diversity of its student body, with larger numbers of students coming from farther away. The student experience has become more varied, as more students study abroad at some point during their time at Wofford. An increased emphasis on arts programming began during the Lesesne administration, thanks largely to Wofford Theatre and the choral music groups, and this intensified under the Dunlap administration, with a strings program and a greater emphasis on the visual arts. The entire campus has been designated an arboretum, and today some 1,450 students study in a campus community that sustains a commitment to liberal arts education.

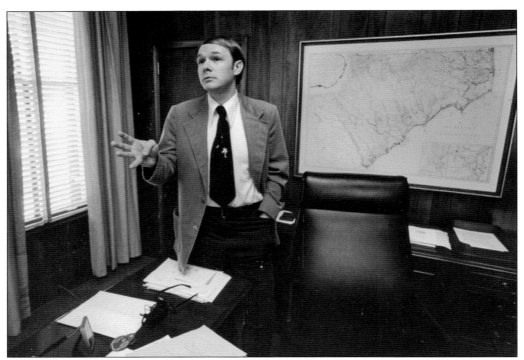

Dr. Joab Mauldin Lesesne Jr. was an Erskine College graduate, but his father and a grandfather both graduated from Wofford. A historian, Lesesne joined the faculty in 1964 and soon moved into various administrative posts. His 28-year presidency saw the college's annual budget increase from $3.5 million to $27 million, the endowment from $3.8 million to $100 million, and 17 buildings or facilities constructed or renovated on the campus.

After graduating from Wofford in 1957, B. G. Stephens earned a doctorate in chemistry and returned to Wofford in 1963. President Lesesne named him dean of the college in 1972, and he served in that post until 1980. He left to become president of MacMurray College in Illinois but returned to Wofford in 1986. He led the college's technology efforts until he retired in 2000.

J. Michael Preston graduated from Wofford in 1963, and after several administrative appointments, he was named dean of students in 1973. His philosophy was to give students the maximum amount of freedom as long as it did not interfere with the rights of others. He stepped down as dean in 1995.

Through the modern era, Wofford trustees have been more than caretakers of the institution; they have been advocates in every way. They identify and recruit major gifts to the college and guide its plans for the future. This photograph shows the trustees in the early 1980s.

Dr. Lewis P. Jones graduated from Wofford in 1938 and took a master's degree from Wofford two years later in an era when the college had a small graduate program. A World War II veteran himself, Jones returned in 1946 to teach the surge of GIs. A historian with a doctorate from the University of North Carolina at Chapel Hill, he wrote, spoke, and taught widely, but South Carolina history was his primary field. Jones served as faculty secretary until his retirement in 1987.

Dr. Vincent E. Miller came to Wofford in 1957 to teach in the English department. In his 32 years on the faculty, he was an inspiring professor, and students who studied under him remembered him helping them find new insights into literature. A seminar room in Main Building is named in his honor.

Several faculty members sit together in a meeting in Leonard Auditorium. They are, from left to right, (first row) Philip Racine, history; Lewis Jones, history; Ross Bayard, history; and Dan Maultsby, sociology; (second row) William Parker, physics; Dan Olds, physics; and Charles Barrett, religion.

Dr. Larry McGehee came to Wofford in 1982 from the University of Tennessee system, where he had been chancellor of the Martin campus. As vice president for development, he helped secure the Olin Foundation grant for the Olin Building. He is better known as a teacher and mentor to a large group of younger alumni who took his "Religion in American Life" seminar each year.

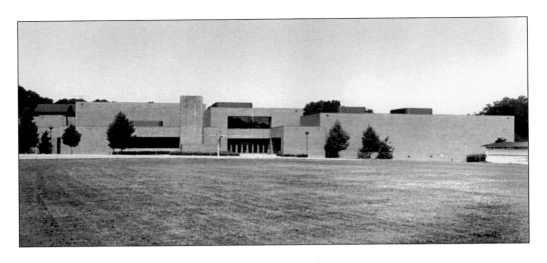

Wofford's Campus Life Building (above) was built to be the center of student life. After ground-breaking in 1979, construction (below) progressed through 1980, with a dedication that November. When it opened, the facility housed the athletics and student affairs offices. Most significantly, the building contains the Tony White Theater, home to the college's theater program; the Benjamin Johnson Arena, home to basketball and other sporting events; the college canteen, Zach's; and a recently remodeled lobby called the Commons. McMillan Theater, a lecture-cinema room, is also in the building, along with a game room.

Opened in 1986, the Neofytos D. Papadopoulos Building houses the alumni and development offices, and is connected to the Hugh S. Black Building on the left. The building was designed to be an alumni center, with a large room that serves as a formal reception space. The trident fountain in the foreground was designed by sculptor Harold Krisel.

Opened in 1992, the Franklin W. Olin Building was constructed with a grant from the Franklin W. Olin Foundation. The building houses the college's information technology offices as well as faculty offices and classrooms. The grant and the building marked a turning point for the college in the use of technology in the classroom.

Constructing the Richardson Physical Activities Building (above) was a long-range goal of the college, and the plans of the Carolina Panthers to hold their summer training camp at Wofford made its construction possible. Opened in 1995 and named in honor of trustee Jerry Richardson and his family, the building has locker rooms for several sports, athletics offices, exercise rooms, and dance studios. The building overlooks Gibbs Stadium (below), which opened in 1996 and is named for the family of lead donors Jimmy and Marsha Gibbs. The stadium seats 13,000 fans.

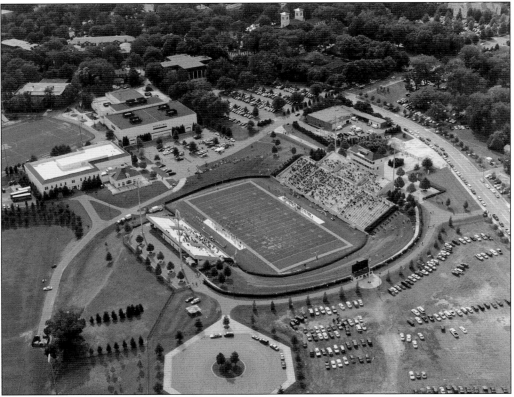

Andrews Field House was remodeled in 2004, and a center door was added to give access to the Anna Todd Wofford Center, Panhellenic Council, and sorority offices. The building also houses a recreational gymnasium, an indoor golf-training center, and offices for the campus safety department.

This dormitory was constructed behind Greene Hall in 1991 and initially housed junior and senior women. As the college has had a tradition of naming residence halls for former presidents, it was named the James H. Carlisle Residence Hall. It features suite-style rooms, where two students share a sitting room and two adjoining rooms share a bath.

This aerial view of campus, taken in 2004, shows the growth of the campus during the Lesesne and Dunlap administrations. The most obvious additions are on the north side of Evins Street, including Gibbs Stadium, athletics practice fields, and the Reeves Tennis Center. In the foreground, the Roger Milliken Science Center has replaced Wightman Hall, and on the left edge, the Papadopoulos building has replaced Snyder Hall. The campus drive has been rerouted, and different trees have been planted. A number of changes, including the addition of the Wofford Village on the north side of Evins Street, have occurred since this picture was taken.

115

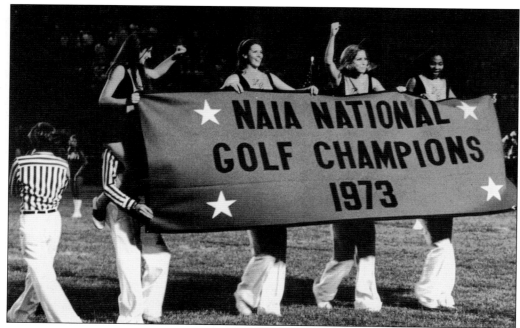

The 1973 golf team won Wofford's only national championship and the first collegiate national championship by a South Carolina team in any sport. This banner celebrates the NAIA championship attained by Vernon Hyman, Marion Moore, Stan Littlejohn, Paul Hyman, and Pat Crowley at the Village Greens Golf Course in Gramling, South Carolina. Earle Buice coached the team.

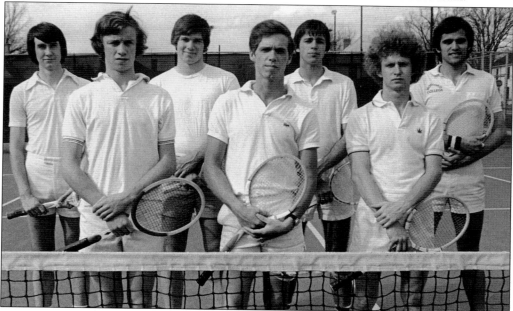

Tennis saw something of a revival in the mid-1970s under a new coach, Jim Newcome. For several years, the college provided no money for a team, but beginning in 1975, funds became available for travel and equipment. Both men's and women's tennis teams continue to field strong players today.

116

The college first began to field women's athletics teams in 1980–1981. The first two sports offered were volleyball (above) and women's basketball. These early teams faced many challenges and were so small that practicing was difficult. Sometimes faculty or students from the men's teams joined in to help fill out practice teams. By the 1990s, these women's sports were established, and women's athletics continued to grow. With Crystal Sharpe as coach, Judy Nwajiaku (below, left) tries to clear the way for Mary Vickers (below, center) to make a rebound at this 1988 game.

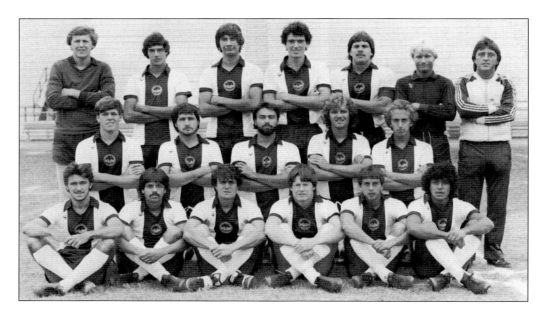

Wofford continued to play in the NAIA through 1987. The soccer team (above) from 1983 was one of the college's men's teams in the 1980s. The college moved to NCAA Division I athletics in 1995 and joined the Southern Conference in 1997. The 2003 football team (below) was the first to win a Southern Conference championship, completing an 8-0 run through conference play and a 10-1 regular season record. Led by coach Mike Ayers, the 2003 Terriers won two playoff games before losing to Delaware in the semifinals.

These are 10 of the 20 students elected to Phi Beta Kappa in 1975. Wofford's Phi Beta Kappa chapter may elect up to 10 percent of each graduating class and generally selects students based on superior academic achievement, creativity, and character. The chapter may also elect a small number of alumni and honorary members.

The number of students receiving army commissions through ROTC began to decline in the 1970s and 1980s, but the program still exists at Wofford. Students at other colleges in Spartanburg also participate, and military science courses continue to attract students.

Residence hall life has become a valuable part of the student experience at Wofford. Today some 94 percent of students live on campus. These students show some of the aspects of residence life in the early 1980s. The first women to live on campus after full residential coeducation occupied the upper floors in Wightman Hall. These women are making the best of the closet and shelf space in Wightman rooms (left). The second group (below) is preparing snacks for a fund-raiser in one of the residence halls.

Wofford's arts programming has grown considerably since the early 1970s. A theater program founded by Dr. J. R. Gross and led since 2003 by Dr. Mark Ferguson has evolved into a theater major. The cast of *Grease* (above) poses for a group picture, taken in 1988. Music has grown under the leadership of Dr. Victor Bilanchone and, since 2001, professors Gary McCraw, Christi Sellars, and Eun-Sun Lee. Dr. Lee's strings program adds to the musical opportunities on campus. Vocal groups, including the Wofford Singers, the Women's Choir, and the Glee Club, continue to entertain the campus community. Below, one of the college's choirs performs in Leonard Auditorium.

Dr. Benjamin Bernard Dunlap (left) joined the faculty in 1993 as Chapman Professor in the Humanities, and in 2000, he was elected the college's 10th president. A Columbia native, Sewanee graduate, and Rhodes scholar, Dunlap earned his doctorate at Harvard. His presidency has seen continued growth in enrollment and improvements in the college's facilities. The arts, studies abroad, and faculty development have all improved under his leadership. Each spring, one student from each major program is selected to participate in the Presidential Seminar (below), which Dr. Dunlap leads. The seminar is modeled on the Aspen Institute seminars that he frequently moderates for corporate leaders. The weekly meeting often invites local business leaders, Wofford faculty members, and friends of the college to participate. Trustee Jerry Richardson (class of 1959, seated beneath college seal) is participating with this group in 2008.

The Roger Milliken Science Center opened in 2001. The new science building has offices, classrooms, and labs for the chemistry and biology departments, as well as Great Oaks Hall, which is a large study space, and the Acorn Café. The original science building has been renovated to provide offices for the psychology and physics departments, and other departments have classes there as well.

Wofford's baseball games had to move off school grounds once the college moved into Division I, but gifts by Russell C. King and the Switzer family brought baseball back to campus in 2004. The baseball field was adjusted so that the outfield would meet Division I specifications, and a new stadium was built, creating Russell C. King Field and Switzer Stadium.

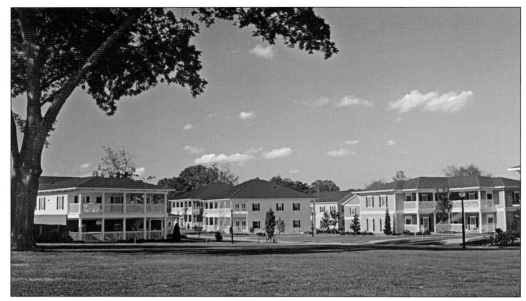

The Wofford Village, which provides apartment-style housing for the seniors, opened in 2006 and has grown in each subsequent year. The village has enough space for the entire senior class to spend a final year in college together, just as they started their college experience together in Marsh and Greene Halls.

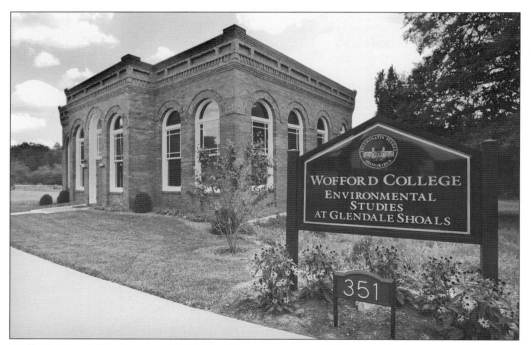

Wofford's Goodall Environmental Studies Center represents the first academic center to be located away from the main campus. The college broke ground on the center and approved a program in environmental studies in 2008. The building, a former mill office, was renovated to LEED (Leadership in Energy and Environmental Design) standards.

Wofford's faculty stands together for the annual portrait on the steps of Main Building at 2009 opening convocation. Dean of the college David S. Wood, appointed academic dean in 2007, and President Dunlap (first row, fifth and sixth from left) lead a faculty with 117 full-time members. In 2009, the college had approximately 1,450 students.

For 27 years, Dr. Dan Maultsby (class of 1961, shown above at center) served as dean of the college. He was responsible for the selection of nearly the entire current faculty. After his retirement in 2007, the college awarded him an honorary doctorate. He is pictured here with (from left to right) trustee chairman Thomas Brittain (class of 1975), registrar Lucy Quinn (class of 1983), and the two presidents he served alongside, Dr. Joab Lesesne and Dr. Benjamin Dunlap.

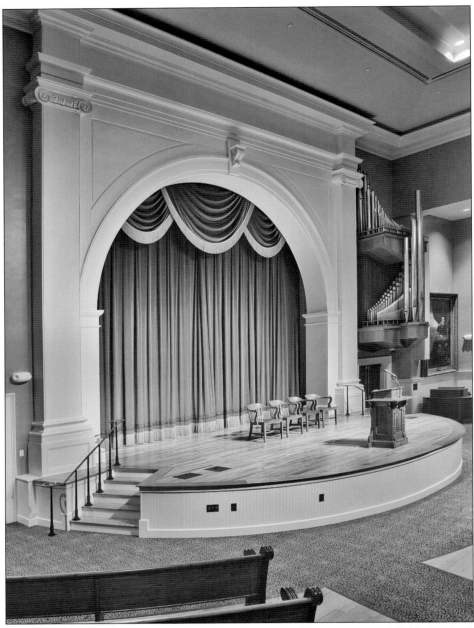

In 2005 and 2006, Main Building underwent another thorough renovation, with half of the building being closed at a time. Classrooms and offices were reconfigured, and the building received a much-needed face-lift. The architects looked to employ some of the building's original design features in the renovation. Leonard Auditorium's chairs were replaced with pews, the stage was enlarged, and better audio-visual equipment was installed. Each former president's portrait hangs in the auditorium, and the William Preston Few Organ provides music for major events. The building's restoration reflects the central place that Main Building has in life at Wofford. Nearly 160 years after Benjamin Wofford decided to found a college "for literary, classical, and scientific education, to be located in my native district of Spartanburg," Wofford College remains true to his vision.

BIBLIOGRAPHY

Boggs, Doyle, Joann Mitchell Brasington, and Phillip Stone. *Wofford: Shining with Untarnished Honor, 1854–2005*. Spartanburg, SC: Hub City Writers Project, 2005.

Coates, Albert. *My Brother, Kenneth*. 1904–1974. 1976. Available in Wofford College's library.

Norrell, Thomas H. "The History of Wofford College: A Small College in the Context of Change." Ph.D. dissertation, University of South Carolina, 1993.

Snyder, Henry Nelson. *An Educational Odyssey: Adventures of a President of a Small Denomi National College*. New York: Abingdon-Cokesbury Press, 1947.

Thompson, Tommy L. *Wofford College: A Time to Remember*. Louisville, KY: Harmony House, 1989.

Wallace, David Duncan. *History of Wofford College, 1854–1949*. Nashville, TN: Vanderbilt University Press, 1951

www.arcadiapublishing.com

Discover books about the town where you grew up, the cities where your friends and families live, the town where your parents met, or even that retirement spot you've been dreaming about. Our Web site provides history lovers with exclusive deals, advanced notification about new titles, e-mail alerts of author events, and much more.

MADE IN THE USA

Arcadia Publishing, the leading local history publisher in the United States, is committed to making history accessible and meaningful through publishing books that celebrate and preserve the heritage of America's people and places. Consistent with our mission to preserve history on a local level, this book was printed in South Carolina on American-made paper and manufactured entirely in the United States.

This book carries the accredited Forest Stewardship Council (FSC) label and is printed on 100 percent FSC-certified paper. Products carrying the FSC label are independently certified to assure consumers that they come from forests that are managed to meet the social, economic, and ecological needs of present and future generations.

FSC
Mixed Sources
Product group from well-managed
forests and other controlled sources

Cert no. SW-COC-001530
www.fsc.org
© 1996 Forest Stewardship Council

Find Your Place in History.